OUTER SPACE PHOTOGRAPHY

For The Amateur

Henry E. Paul, Ph.D.

Fourth Edition

AMPHOTO
American Photographic Book Publishing Co., Inc.
Garden City, New York 11530

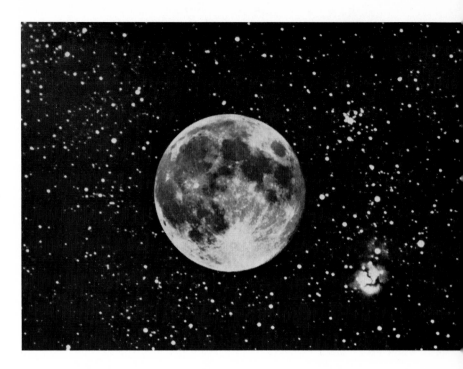

Fig. 1. Photographers are now training their cameras on our natural satellite the moon and the nearer planets as astronauts venture farther and farther into outer space.

Plan.
QB
121
P324
4th. ed.

Library of Congress Catalog Number: 67-21698

ISBN: 0-8174-2407-5

Manufactured in the United States of America

TABLE OF CONTENTS

 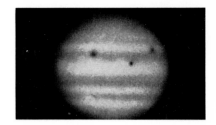

Fig. 2.

ACKNOWLEDGMENTS

A preface by a "name" individual often introduces a book, possibly to increase its status. It seems much more appropriate instead to use this space to thank the many amateur photographers whose excellent work presented here over their names has certainly made this a more valuable book for other amateurs, hobbyists, students and educators.

The very extensive work of a few enthusiasts, such as S. R. B. Cooke, C. P. Custer, M.D., Ralph Dakin, Paul Davis, R. and D. Davis, A. Dounce, George Keene, Evered Kreimer, Alan McClure, Tom Osypowski, Walt Semerau, E. C. Silva, and newer contributors such as J. Rouse, E. Ken Owens, B. Lundergard, S. Schultz, and the staffs of NASA and Celestron, has been invaluable in the area of outer space research. Examples of this work are the stereo-effect photos of Jupiter (above) and correction of atmospheric dispersion (below) by Horace Dall of Luton, England. Other outstanding work appears throughout the book.

The encouragement and editorial assistance of M. Dembling, L. Kaplan, and H. Taylor, and the aid in manuscript preparation by M. L. Oliver, were most valued contributions.

HENRY E. PAUL

Fig. 3.

INTRODUCTION

This book is specifically designed to encourage the amateur photographer to try his hand at the rapidly growing hobby of space age photography, and to guide him—and her—in the use of readily available photographic equipment and telescopes.

The interested amateur can take pictures that command as much attention as those made by large observatories. This pleasant pastime may become a real scientific contribution. Many outstanding discoveries concerning outer space have been made by amateurs since the early ages. An unidentified object may streak across the sky, a large meteor flash through the heavens, a comet burst forth, or a nova flare up. Your camera has the same opportunity of capturing these as anyone else's.

Over half of this volume consists of outer space photographs by the author or other amateur photographers. It is believed that the reader will be more interested in seeing the accomplishments of other amateurs, rather than seeing the repeatedly presented photographs taken with the highly specialized instruments of large observatories. Almost any area of astronomical photography may be tackled with very modest equipment as long as it is used with interest, determination and a bit of guidance.

Any constellation you choose can now be photographed in a few seconds as a result of the recently developed black

and white films with exposure indexes of *over 1000,* using an average camera without any accessory equipment whatsoever, as described in Chapter 9. A Polaroid camera now permits completed constellation photographs for your own minutes. New color film having an exposure index of over 400 at last presents unlimited opportunity for color recording of outer space objects. Use High Speed Ektachrome for "cold" cameras.

Since most who start in astronomical photography like to select an area of their own interest in which to work, such as photographing the moon or sun, etc., this guide has been organized by subject, with work for simpler cameras appearing first, in the faith that pleasure and success here will lead one on to the types of outer space photography requiring greater skill and additional equipment.

The author has preferred to make specific reference to a limited number of economical sources of information of an educational nature (some free) and equipment which he has found useful and can recommend, realizing that there are many other sources, some possibly better, which, because of lack of space, could not be mentioned in this little book.

As examples, if the amateur astrophotographer were to limit himself to a single magazine, then the outstanding monthly journal *Sky and Telescope* is specifically recommended—included every year in its January issue is the very useful Maryland Academy of Sciences Graphic Time Table of the Heavens to locate sky objects. As a single sky handbook, *Norton's Star Atlas* is recommended. Journals such as the superb *Astronomy* or *Modern Photography* should also be reviewed. For miscellaneous equipment turn to Edmund Scientific Co., A. Jaegers, and Optica b/c.

Useful formulae and other detailed information have been gathered in the appendix for ready reference. Here too is a handy index of addresses of suppliers mentioned in the text.

Lens and object-instrument reference tables appear on pages 23 and 103.

1

BACKGROUND

In entering the realm of outer space photography, the amateur photographer has a few new factors to consider. Perhaps first of all is the fact that all celestial objects are moving objects with respect to the camera or telescope. The rotation of our earth on its axis makes the celestial objects seem to sweep slowly across the sky from East to West. This is the most important motion for us to consider.

Before proceeding further let me emphasize that many kinds of interesting outer space photography may be accomplished completely ignoring the above celestial motion; for instance, photographing those bright sky objects where light is ample and exposure time can be shorter than a few seconds for small cameras and a few tenths of a second for most amateur telescopes, or where it is the motion of the object itself that is to be recorded. Amateur photographers with ordinary cameras or fixed telescopes on steady mounts can photograph the moon, sun, sunspots, eclipses, meteors, Northern Lights, satellites, star trails, etc.

Any kind of camera can be used in astronomical photography and I have seen fine pictures taken with most types of cameras. Fig. 4 is an example. Where maximum sharpness is desired it is best to confine the use of film to still cameras from 35 mm. up to about 2¼ x 2¼ size, using plates in larger cameras. This is because film does not tend to be held flat enough (at the focal plane) in the larger size

3

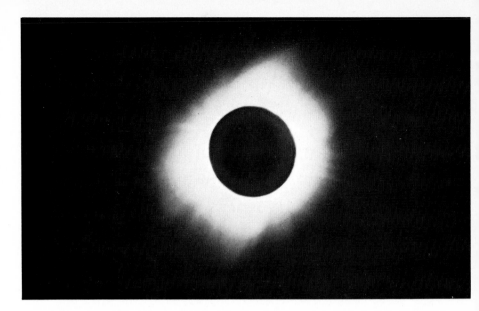

Fig. 4. Solar Corona: Streaming coronal halo at total eclipse of Oct. 2, 1959. Taken at Canary Islands, using 210mm f/4.5 Zeiss Tessar, Exakta Varex camera, 1-sec. on Adox Dokupan. Photo by Fritz Laudenklos, Cologne.

cameras unless these are specially designed. The popular modern single lens 35 mm. reflex camera, especially with interchangeable lenses and viewing screens, is practically ideal for use in many kinds of outer space photography. I highly recommend such reflex cameras for the amateur starting astrophotography with the reservation that shutter recoil or "jar" must be considered. Look for review articles or summaries on the latest models of reflex cameras in *Modern Photography* or *Popular Photography*. Consider Nikon, Olympus, Canon, Miranda, and Pentax.

A few broad statements should be made regarding lenses, although this subject will be reviewed in detail elsewhere. Perhaps in scientific astronomical photography more than in any other field the old statement that "The best is none too good" applies; therefore, it is the best policy to start with a high quality lens. Most modern fast (largest aperture consistent with focal length—and one's pocketbook) "accepted name" lenses in the medium or upper price bracket will be satisfactory, particularly if the lens opening is closed down one-half to one stop (depending on the lens) from full aperture in those instances where extreme definition is required.

Lenses for astrophotography should be at least one inch in diameter and preferably larger. For photography of the

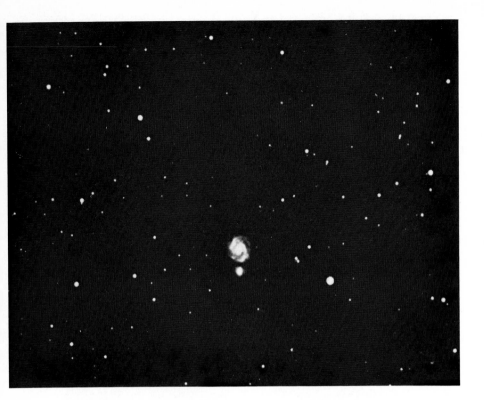

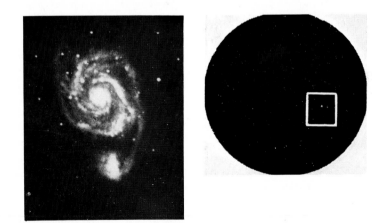

Fig. 5. (top) "Whirlpool Nebula," M51 in Canes Venatici. 30-min. exposure on Eastman 103aE emulsion, 10-in. focus f/2.0 Schmidt, 16X enlargement.— Fig. 6. (right) Contact print and approximate area of enlargement. Photos by the author.—Fig. 7. (left) Same object with 20-in. aperture, 120-in. F.L. f/6 reflector, 2½-hr. on Eastman 103aO. Photo by E. C. Silva, Portugal.

distant planets telescopes using lenses or mirrors of 6-inch or greater diameter and proportionately longer focal lengths are most desirable—not just because of increased image size but primarily for the increased resolving or defining power of the larger lens. (See Fig. 5) Discussions that would fill this entire book have been concerned with relationship of aperture to resolving power and how aperture can limit what one can see and photograph—even granting perfect atmospheric conditions. In brief, the larger the aperture or usable area of a lens (or mirror) the greater its ability to resolve fine detail on planets, separate close double stars, etc. The value 4.5 divided by the lens opening diameter in inches provides one with the approximate minimum angle of separation in seconds of arc which objects must have in order to be distinctly separated or recognized as separate lines, marks, or points (as double stars). A 4.5 inch diameter objective then clearly shows as two stars those that have an angular separation in space of one second of arc or more—or objects about an inch apart at 3 miles! Poor atmospheric conditions or thermal air currents in an instrument can greatly reduce such theoretical limits. On page 113 Horace Dall graphically illustrates aperture-resolution relationships.

Film speeds and characteristics must be considered, particularly where long exposures are required. The standard values for film speed may be used with confidence in a large part of outer space photography where exposure times of fractions of a second or even one second are used. However, when light is very faint and exposures run into a number of minutes, or hours, the usual A.S.A. (or other) speed values no longer hold true. The breakdown of our well learned rule of thumb approach (in which we expect twice the exposure time to make up for half as much light, or to produce twice the film density with the same light) is known technically as "reciprocity law failure." Films vary greatly from one to another in such failure and comparative values are not available. A relatively slow contrast process panchromatic film may produce a better exposed Milky Way star picture after 15 minutes exposure at $f/2$ than the fastest rated panchromatic film—with added dividends of the sharpness and contrast of the finer grain film. Actually we can proceed with little concern when making long time exposures by staying with the medium speed finer grain more contrasty films,

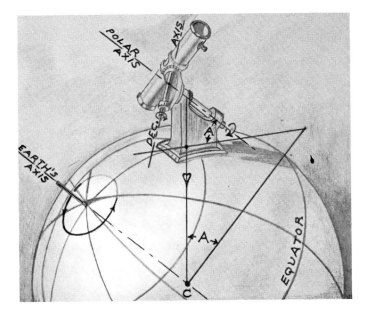

Figure 8

THE "WHY" OF THE EQUATORIAL MOUNTING

First, in any equatorial telescope, the angle A, between the polar axis and the northern horizon, must equal the observer's latitude. Once adjusted thus, it need never be touched—unless the telescope is moved to another latitude. The polar axis is now parallel to the earth's axis, and although these are several thousand miles apart, this makes no appreciable difference in observing objects millions of times as far away. Having now eliminated this factor, any star may be followed by slowly revolving the declination axis and telescope tube as a whole around the polar axis. Whether we now choose to point the tube high or low in the skies makes no difference—wherever it is, its polar axis is always performing the necessary slow motion to offset the earth's daily rotation. Polar axis rotation angle in hrs. and mins. = "Rt. Ascension." Distance from celestial equator N(+) or S(—) in degrees = "Declination."

Adapted from Amateur Telescope Making Book One. Courtesy Scientific American Publishing Co.

which generally seem to give better over-all performance with long exposures. Eastman Kodak supplies special emulsions for astronomical work, some of which are especially processed to respond remarkably well to faint light. (Booklet—*Kodak Photographic Plates and Films for Science and Industry*. Read carefully the ordering instructions, particularly as regards "backing," shipping, storage, and minimum film orders.) Such emulsions are designated by the letter *a*—example 103*a*E instead of 103E. For star work "antihalation backed" *must be specified* to avoid halation rings around stars. The fine conjunction of the Moon and Venus photographs by Tamie A. Smith of Fig. 9, besides being picturesque and showing earthshine on the Moon, also serve educationally. The long exposure photo illustrates spider diffraction (the cross effect on Venus), and halation effects (arcs near Moon crescent and ring around Venus) caused by light going through the emulsion to be reflected from the plate's back surface to form halation arcs or rings. A special coating on the back will greatly reduce this effect. (Fortunately for our illustrative purposes Mrs. Smith had no antihalation "backed" plates available at this event.)

The length of exposure in astronomical photography is, of course, eventually limited to stray sky light. I like the characteristics of Kodak's High-Contrast Copy film with fast large special lenses where plates cannot be used.

Developing your own film or plates, while not absolutely essential, will pay greater dividends in this area of photography than in most others. Such home development speeds up your progress, leads to high quality negatives, and gives you the personal satisfaction of knowing almost at once the result of your photographic trials. I have often taken and developed, one at a time, a half dozen or more films or plates in one evening to obtain the desired negative. The large number of variable factors affecting exposure time and image definition make it most unusual to obtain a "finished" photograph on a first try. Light meters are seldom useful. Experience with your own equipment and a particular area of photography greatly reduces the error in this trial and error procedure.

The keeping of written records as you go along will prove very helpful. All data such as date and time, camera, lens, aperture, film, exposure time, development, etc., should be

8

filed with each film. You will be surprised how often these data will be referred to—particularly after some lapsed time.

Filters have their place in astronomical photography, although the need differs somewhat from common usage. One use is to correct lens defects. When cameras using panchromatic film are adapted to ordinary refracting telescopes, a yellow filter (Kodak's or Tiffen's No. 12—"minus blue") should be used to filter out blue light, to which film is very sensitive but which is not brought to a sharp focus along with the other colors. Use of a proper yellow filter will produce sharper star images. To avoid interfering with the definition of good astronomical objectives filters must be of lens quality —or gelatin film. Most ordinary filters should be used as near the camera or film as possible. The above use of filters does not apply to smaller telephoto lenses corrected for camera use. Fortunately the reflecting mirror telescope may be used without correction filters since it is perfectly color free or achromatic. Nikon, Tiffen, Vivitar, and Vernonscope are all excellent.

Another use of filters is nearer that of common photographic practice. A yellow filter will greatly reduce sky light caused by moonlight scattered by particles in the upper atmosphere. Filters plus appropriate films permit separation of different colored stars, isolating certain sky objects, and bringing out special details, as shown in Fig. 10.

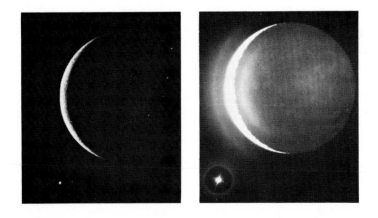

Fig. 9. Conjunction of Moon and Venus, March 12, 1959. 12-in. aperture f/6.7 reflector telescope (left) 1/5-sec. on 103aF plate, (right) 2-sec. on 103aO plate. Photos by Tamie A. Smith.

Most photographers are familiar with the emphasis on a steady tripod for time exposures. The need for a sturdy, rock steady support for cameras or telescopes in most astronomical work is even greater and *cannot be over-emphasized.* Care should particularly be exercised in the selection of tripods where larger cameras or long focus lenses or telescopes are used. Jarring of the camera by shutter operation (including recoil) during time exposures can further be avoided by holding a shield or lens caps in front of, but not touching, the lens during the shutter opening and closing operation—much as the "Gay 90's" portrait photographers did. Military surplus tripods are often substantial and very good "buys," being readily adapted to use.

Where longer exposures are required than those indicated at the start of this chapter, as for nebulae, planets, etc., the camera or telescope must be made to follow the motion of celestial objects by a guiding or driving mechanism, or both. The apparent motion of general sky objects is greatest near the celestial equator, the approximate path of the sun and moon, and decreases to nothing at the North Pole. The image of a planet at focus of a 6 inch aperture 48 inch focal length common reflector will move enough in one second to reduce definition. In the northern hemisphere with the North Pole well above the horizon the stars actually appear to travel in ever widening circles about the true pole, with our so-called North Star (Polaris) moving in a circle about 1 degree in radius. Following celestial objects is usually accomplished by fastening the camera or telescope to a suitable drive or mount with one axis (Polar—parallel to the earth's axis) rotating at one revolution per day from East to West to follow the object and keep the image at the same identical point on the film. The role of such an equatorial mounting is best illustrated in the sketch adapted from Russell Porter— Fig. 8. *Right Ascension* and *Declination* positions an object.

The basic methods of using photographic equipment in space photography are as follows—ranging from simple to complex:

A. With *fixed* rigid camera support:
 1. Your camera alone with standard lens, or with telephoto or wide angle lenses—where such can be added.

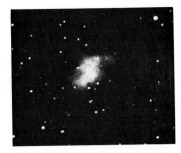

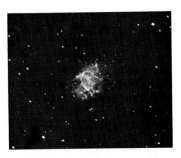

Fig. 10. The Crab Nebula M1 in Taurus, photographed in blue light (left) and red light (right). Note increased detail in red light photo. 20-in. aperture 120-in. focus f/6 reflector. (left) 100-min. Super Fulgur plate, no filter. (right) 90-min. 103aE plate, Wratten 29 red filter. By Eugenio C. Silva, Portugal.

 2. Your camera working through a binocular, spotting scope or telescope.

B. With camera on an equatorial mounting *driven* to follow celestial objects; usually a guiding telescope corrects any errors for extended exposures.

 1. Your camera and lens mounted *on the side of* a driven telescope.

 2. Your camera, with or without its lens, working *through* a driven telescope.

 3. By special astrographic cameras—usually driven and guided.

Let us now review briefly the lens *systems* most useful to the amateur in astrophotography. Such "optical trains" are actually quite simple to assemble, consisting of a *main light collecting lens* (or mirror), *intermediate lenses* (such as your camera lens and/or eyepiece) and a *camera* box. Figure 11 illustrates in a diagrammatic manner four of the more common optical lens systems using an ordinary achromatic long focus refractor telescope lens as the primary light collector. The mirror of a reflecting telescope could serve the same purpose in collecting light as does the simple telescopic lens illustrated here. All systems as presented have the same *equivalent focal length* and produce the same image size, but are not to scale.

(a) Illustrates the simplest telescopic lens setup. A 35 mm. reflex camera *without lens* completes this arrangement. This photographic setup is particularly desirable for use with telescopic type lenses or mirrors having focal lengths of 50 inches or longer. One of 90 inches focal length produces an ideal sized image of the moon on a 35 mm. frame (see Fig. 58, page 61). One of the advantages of this system is that no light is lost or scattered by extra lenses in the system nor are the aberrations of added lenses (unavoidable even in the best of lenses or eyepieces) present to detract slightly from final image sharpness. The over-all simplicity of this system speaks for itself.

(b) Here is presented a common method of coupling a camera *with its lens* directly to the eyepiece of a complete telescope. This system is particularly applicable for use with shorter focal length telescopes as rifle range spotting scopes, or with one half of a binocular, to increase the image size on your film (over what your camera lens would give alone) by the magnification of the instrument—as indicated on the eyepiece for that instrument. Higher magnification eyepieces (shorter focal lengths) will give proportionately larger images on the film. Longer focal length camera lenses may also be used to increase the image size; of course the converse in each case reduces the image size. The image size may be computed by use of suitable formulas from the Appendix. The camera and telescope must be focused at infinity—the latter requirement needs special consideration.

(c) The so-called projection method as illustrated requires a camera to be coupled *without its lens* and so arranged that the eyepiece (or projection lens) with camera

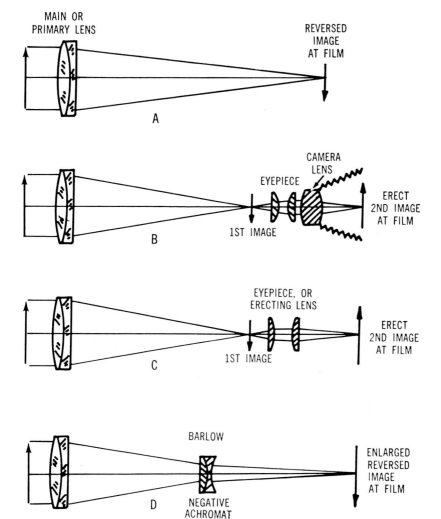

MAIN OR
PRIMARY LENS

REVERSED
IMAGE
AT FILM

A

CAMERA
LENS

EYEPIECE

1ST IMAGE

ERECT
2ND IMAGE
AT FILM

B

EYEPIECE, OR
ERECTING LENS

1ST IMAGE

ERECT
2ND IMAGE
AT FILM

C

BARLOW

NEGATIVE
ACHROMAT

ENLARGED
REVERSED
IMAGE
AT FILM

D

Fig. 11. Four lens systems most commonly used in astrophotography. See text.

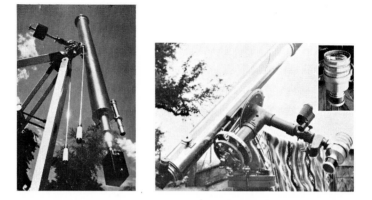

Fig. 12. A 5-in. aperture Alvan Clark refractor fitted with a simple box camera plate holder.—Fig. 13. (right) The author's first high-speed star and nebula camera (1939) with 180mm Zeiss Sonnar using round plates in focus checking attachment (insert). Alvan Clark 3½-in. refractor guide scope on sidereal driven equatorial mounting.

can be "backed up" until an image falls in focus at the focal plane of the camera. The image on the film is increased in size as the distance between the eyepiece and the film increases and also by the use of shorter focal length (higher power) eyepieces or lenses. These two variables may be juggled about by trial and error to obtain what you desire as to image size; or use formulas in Appendix and measure distances—then make final fine adjustments. Orthoscopic eyepieces are recommended. The 50 degree field Brandons (Vernonscope) are my favorite. Parfocal take filters.

(d) Often overlooked but having considerable merit, simplicity, and flexibility is the use of a negative *achromatic* (Barlow) lens as shown in Figs. 15, 16. This negative lens (concave side toward camera) is placed just inside the normal focus of the telescope lens and as it is moved in toward the objective the resultant image moves farther back and at the same time increases in size. For use with the 35 mm. reflex camera such Barlows should be about 1 inch in diameter and from 3 to 6 inches in *negative* focal length (as available) for ordinary refracting type telescopes, and 1½ to 4 inches negative focus for reflecting type telescopes. The 2.4X Dakin Barlow, which is manufactured by Vernonscope, best serves any of these purposes. Over-all mechanical

14

Fig. 14. Orion area; 1-hr. exposure on ultra-speed Pan, Zeiss Sonnar 180mm, f/2.8 lens on Contax. Enlarged from 35mm. frame (insert).

instrument length, for the size of the image produced, is greatly reduced. Our diagram also illustrates true telephoto lenses—which contain such a negative element, making their physical length shorter than their true equivalent focal length.

Since three of these four "systems" use no regular camera lenses the so-called "camera" could be only a box type film or plate holder. The excellent photographs in Figs. 75 and

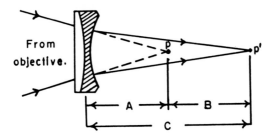

2X Barlow amplifier.

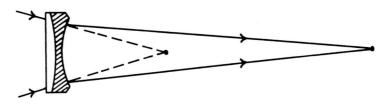

3X Barlow amplifier.

Fig. 15. (above) Use of a negative lens (achromatic Barlow) as an amplifier. Fig. 16. (below) Shifting this same lens towards the objective increases the magnification. For complete explanation and formulae, see page 121.

129 by Paul Davis, pages 74 and 110, were made using a simple box camera (without lens) coupled to a superb 5-inch Alvan Clark refractor Fig. 12. In these instances, Mr. Davis's long experience as a top ranking commercial photographer undoubtedly also contributed. My first high speed setup for nebula photographs (7 inch $f/2.8$ Zeiss Sonnar Fig. 13) simply used the ground glass focus checking unit as a round plate holder. With it the nebula and stars of Fig. 14 were taken 20 years ago. Compare it with Fig. 93, page 86 taken more recently with my 10 inch focus $f/2$ Schmidt as shown on pages 26 and 27. Nevertheless, the modern single lens reflex camera without lens provides a much more convenient means of obtaining sharp focus.

The usual amateur reflecting telescope from 6 to 12 inches in aperture and focal lengths from 48 to 90 inches is very amenable for use with the image falling directly on the film as in Fig. 11, as stated earlier. The resultant moon or sun image diameter of from four-tenths to eight-tenths of an inch when taken on a fine grain film such as Kodak High Contrast Copy Film may be enlarged to almost any size. It is convenient to approximate the image diameter of the sun or moon as a hundredth the focal length. Color film provides beautiful projection material.

Each method described has its advantages (and limitations) for the areas of outer space photography as covered by the following chapters where the easier approaches are presented first. (See Edmund Scientific Co. for excellent low cost books by Sam Brown.) Many areas are "naturals" for standard photographic equipment. Others, such as photography of planets and faint distant nebulae, can challenge even the well-equipped, experienced amateur.

In this hobby, as in any other, I'm sure there will be disagreement with the many seemingly dogmatic specific statements made, primarily to initiate an early start at outer space photography before too many "ifs, ands, and buts" inhibit the reader. This small book does not permit the numerous modifying clauses and exceptions most true scientists prefer to tie protectively to a direct statement. There are more often than not different methods of obtaining similar, and sometimes better, results in photographic work. New trials, new material, and new equipment lead to constant improvement.

The element of DANGER to one's eyes in studying our sun should be referred to at the start of Chapter 7 by all who are not aware of this hazard.

Speaking of hazards, always have tripods *firmly* planted in the ground, or fitted with strong check-chains. Otherwise, in the dark running dogs, children, or stumbling adults will wreck both themselves and your instrument. Always "steady" observing ladders and their occupants when children, most women, or the elderly are engrossed in a "first thrilling look."

Recent books you should have are Dr. Henry E. Paul's *Telescopes for Skygazing* (Amphoto) and George Keene's *Stargazing with Telescope and Camera* (Amphoto).

Fig. 17. Wide angle photograph covering 50° of the southern Milky Way centered on the Scutum starcloud. A Perseid meteor flashed down the center during the one-hour exposure. The bright object in the lower right is Jupiter. 6-in. Bausch & Lomb f/6.3 Metrogon at f/8. 103aE Special Antihalation backed plate, developed 6-min. in D-19. Photo by the author.

2

LENSES — CAMERAS — TRIPODS

The statement made by myself and others that any good camera and lens may be used in astronomical photography is quite true; yet it can be as misleading as stating that any good gun will do for hunting. One can shoot at a rhino with a .22 or attempt to photograph star clusters with a standard 35 mm. camera. While both attempts are at best futile, the latter is at least not dangerous. It's wise to choose an area of astrophotography most suited to one's equipment —or better yet to select equipment most suited to do the job in your area of interest. *There is no "all purpose" astrographic camera.* The wide angle photograph of Fig. 17 was taken with a camera and lens designed for this use.

No sharp line of demarcation exists between lenses, cameras and telescopes in equipment designed for outer space work. To illustrate—any light-tight box with an appropriate lens on one end and a film holder on the other is a *camera.* An elegant telescope may be coupled with a simple box camera for effective work (see Fig. 12, page 14), or an expensive 35 mm. camera may be coupled to a low cost war surplus achromatic lens of 2 inches or more diameter and again do striking work.

The Schmidt camera discussed later moves even farther away from the usual lens-camera concept. Much depends on the worker and what he wishes to accomplish with what is available—here is a real opportunity for individualism.

In this chapter we will consider instruments used for photography *only*. In the next, the adaptation of long focus visual lens or mirror systems to photographic purposes—an arbitrary division.

LENSES

For our work a lens of *at least* one inch effective front opening (clear aperture) should be chosen. A two-inch focal length $f/2$ lens, or a four-inch $f/4$, or even a sixteen-inch $f/16$ lens would fill this requirement—the latter example could, of course, be an ordinary one inch aperture visual refracting telescope objective.

Very useful work can therefore be done in general sky

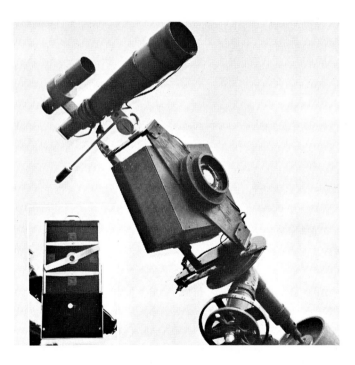

Fig. 18. Wide angle star camera and drive with finder and guide scope. Made by the author. A 6-in. Bausch & Lomb Metrogon f/6.3 lens on precision built camera box using the 8x10 plateholder shown in the insert. Guide scope takes 40X eyepiece and illuminated single silk crosshair. See Fig. 17.

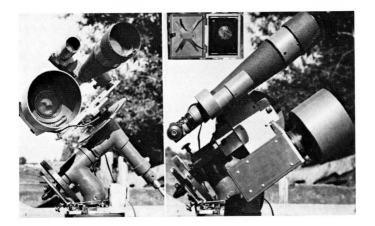

Fig. 19. A satisfactory astrographic camera for general use. 7-in. f/2.5 Eastman Aero Ektar lens screws into a bakelite camera box to adjust focus. 4x5 plate fits directly into back using loading hood. Insert shows spring fingers to hold plate against adjustable stops. Two 1-watt 12,000 ohm resistors taped to lens serve as 110 volt anti-dew unit. Guide scope as in previous photo.

photography with cameras ranging from the fast 50 mm. lenses of 35 mm. cameras to $f/4.5$ lenses in cameras using about 4 x 5 plate or film size, since these all have apertures of about one inch or more. It will be noted in chapters to follow that often greater light gathering power and greater magnification (longer focal length) than provided by lenses of the one inch aperture is desirable. In these instances lenses of from 2 to 5 inch effective aperture are much to be preferred.

At this time it should be explained that a difference exists between our common understanding of the "speed" of a lens in regular photography versus "speed" in the photography of true point sources of light—as the stars. My explanation will probably be as dry and uninteresting as others I've read; however, because of the importance of this basic new information to all of your work with stars it is hoped the reader will follow along for a couple of short text-bookish paragraphs.

Where objects in the sky, such as the moon, planets, large nebulae, etc., covering an extended area are photographed, our regular understanding and use of f-numbers still apply

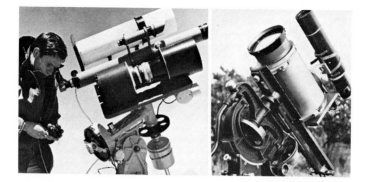

Fig. 20. Alan McClure with astrographic unit. Near camera, 12½-in. f/3.5 Aero-Xenar; for camera, 20-in. f/5 Goto-Tessar. Guide scope 3-in. f/14 refractor. Photo by Roy K. Ensign.—Fig. 21. Eastman Aero-Ektar 12-in. f/2.5 astro camera as used by Paul W. Davis. Bausch & Lomb 60mm spotting scope for guiding.

—that is an $f/2.0$ lens is twice as fast as an $f/2.8$, which in turn is twice as fast as an $f/4.0$, etc. Accordingly a two-inch aperture four-inch focus ($f/2$) lens has the same speed and will produce the same image density (but twice the image size) for a given exposure time as a one inch aperture two-inch focus ($f/2$) lens. We are all rather familiar with such usage.

The story is quite different when photographing true point sources of light, as the individual stars.

Here the light intensity of the image at the film depends primarily on the area of the lens or objective and not on the focal length. Since the area of a lens is proportional to the *square* of its diameter we now find that the two-inch aperture four-inch focus ($f/2$) lens described above becomes *four times* as "fast" for point star images as the one inch aperture two-inch focus ($f/2$) lens. Expressing this differently we also find that any two-inch aperture lens will have the same "speed" for point stars independent of whether its focal length is four inches, eight inches. or sixteen inches; i.e., whether it is an $f/2$, $f/4$, or $f/16$ lens—hence the size (effective diameter) of the lens and not its f/value is the controlling factor in true star photography. With the increase of focal length stars will be accordingly more widely separated

LENSES FOR ASTROPHOTOGRAPHY — USED OR SURPLUS

Make or Type	Focal Length	f/ratio	Comments
Express W.A. (Ross)	5" and 8¼"	4.0 "	Good semi-wide angle lens; Stop to f/5.6 to cover 4 x 5. 8¼" covers 5 x 7.
Metrogon — W.A. (Bausch & Lomb)	6"	6.3	Good wide angle astro lens — Covers up to 9" x 9" plate satisfactorily at f/8 — residual astigmatism not objectionable in off axis images.
W. A. Survey (Ross)	6"	5.5	Stopped to f/6.3 should do as well as above at f/8 because of extra element (not thoroughly tested).
Aero-Ektar (Eastman)	7" (also 12")	2.5	7" is ideal beginner's lens; economical in price; spher. aberr. clears at abt. f/3.5; coma at abt. f/4.0 — best all-around stop; at f/5.6 covers 4 x 5 except corners; where diaphragm not available insert fixed stop between front and rear lens units. 12" similar.
Broad Group Aviar (Cooke) Ektar (Eastman) Xenar (Schneider) Express (Ross) Dogmar (Goerz) Tessar (Zeiss and other makes)	8" to 24" or more	4.5 recom-mended	Large lenses to bargain for in shops. Such lenses in f/3.5 speed usually not a better buy. Avoid very fast older lenses except for narrow angle work or if fills your special need — after test! Stop down f/4.5 lenses to f/5.6 and even f/8.0 where greater off axis sharpness desired. Thoroughly test. Avoid portrait lenses.
Zeiss Triplet	20" 27½"	4.8 5.0	Worth investigating individually for 4 x 5 plate size; try with various filters.
Aero Tessar (B&L) and Aero-Ektar (EK)	24"	6.0	Readily available; Judge on individual test basis — can vary; closing ½ stop and/or using red filter plus fast red emulsion 103aE may greatly improve performance. Also try lt. yellow filter + ortho emulsion with Ektar.
Dallmeyer Telephoto	36"	6.3	Good for narrow angle. Stop to f/8 to reduce spher. aberr. Works best in yellow and red light.
Larger Lenses	40"+	5+	Must test on individual basis trying various stops and filters to see if useful to you; Buy only on this basis — or take a chance.
Old Petzval Portrait Lenses — brass barrel	20" to 36"	3 to 6	Very cheap for size. If true Petzval formula can cover 10-20° well wide open if film against, or near, flat surface of added "field flattener" lens. Other surface of field lens concave to radius ⅓rd focal length — See ATM. Book Three.

Avoid low reflection coatings on older large lenses because warping may occur. See source listings at the end of this book or *Sky and Telescope* for low reflection coatings.

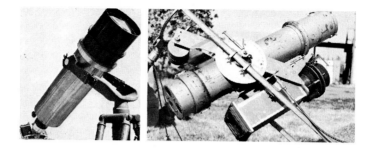

Fig. 22. Dallmeyer 36-in. f/6.3 telephoto plus Exakta camera adapted to a yoke mount for astrophotography. Photo by Paul W. Davis.—Fig. 23. f/6, 24-in. Aero-Ektar camera slung bomb style under a reflector guide scope as built by Clarence P. Custer, M.D. Newer Schmidt-Cassegrainian units are superb.

but the star image film density will theoretically remain the same.

In summary, with extended objects our usual lens "speed" aperture ratio evaluation method holds true. However, when photographing faint stars, larger diameter lenses have a marked advantage. Separation of the stars will still proportionally increase with the focal length, in the same sense as image size does in our usual evaluation of lens functions.

We now know *why* larger aperture lenses are recommended for faint star work and why a minimum of one inch aperture has been recommended. We also know why astronomers usually refer to lenses and telescopes by the all important lens *diameter*—they are not just being different. Therefore a 3, 4, or 6 inch, etc., instrument refers to the effective lens opening and *not* the focal length, with the focal length or f/value usually mentioned secondarily—in contrast to a usual photographer's mention of focal length followed by f/value. Since both methods will have to be used in this book it is well to be on guard. To find the effective or clear aperture of a lens divide its focal length by its f/value. The actual measured diameter of some wide angle lenses is often misleadingly large. In astronomical photography we will therefore most likely use our lens at the fullest available aperture. In special instances it is desirable to stop the lens down to reduce excess light or to improve off axis definition and accordingly sharpen the corners of our negatives.

The subject of lens design versus definition (or quality)

for astrophotography is a topic all to itself and can be touched upon only briefly here. This area is reviewed in detail in my "Notes on Lenses for Astronomical Photography" (*Amateur Telescope Making—Book Three—*Scientific American, Inc.). Most presently manufactured regular camera lenses in the upper and middle price brackets should perform satisfactorily; however, large ones can be *quite* costly.

A plate or film holder size of 4 x 5 inches is recommended as being ample in size to cover the usable area of good definition of the ordinary available photographic lenses regardless of focal length. This plate size may be "stretched" to 5 x 7 inches for certain uses. The above recommendation is a *general one* based on broad experience; however, I have used an 8 x 10 inch plate holder on the home built camera of Fig. 18 using a selected 6 inch focal length wide angle lens to cover large areas of the sky for satellite or meteor work (see Fig. 17)—hence, it's hard to make rigid rules in such a varied field.

Those who wish to attach a large photographic lens of their choice to a plate or film holding device (light-tight camera box) as shown in Fig. 19 should look into the so-called "surplus" and used lens market, unless one is in unusually good financial state. Most productive sources would be the ads in the journals *Sky and Telescope, Astronomy,* and *Modern Astronomy,* and Edmund Scientific Co. and A. Jaegers (see Introduction).

A visit with Alan McClure in California recently convinced me he had tested as many and as varied lenses as I, and used these even more—while I turned to Schmidt cameras. One of his photographic "setups" is shown in Fig. 20. The excellence of his work with large photographic lenses is attested to by his photographs of nebulae and comets in Chapter 10. We have worked together to provide the list on page 23, containing brief comments as a guide. These are a few of the more available lenses worth considering.

The Eastman $f/2.5$ aerial Ektar in the 7 and 12 inch focal lengths has proven quite popular where a fast economical lens for dim nebular objects is desired. It can be stopped to $f/4.0$ or more for critical star work. This 7 inch size makes a good beginner's lens. A 4 x 5 inch plate size is ample for either. The 12 inch size ready for action is shown in Fig. 21. Many other large long focal length surplus lenses have re-

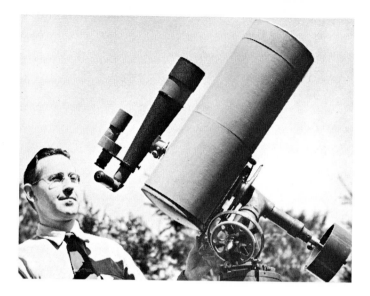

Fig. 24. Completed f/2 Schmidt camera, guide scope and drive, ready for action. Used to make Fig. 108A and other photographs throughout this book.

cently been released and should be interesting to try. Figs. 22 and 23 show use of the longer focal lengths. I'd like to see other workers' results with these.

To test a lens quickly for a "guestimate" as to possible performance make an artificial star by piercing the finest possible needle hole in a piece of aluminum foil and placing this over a 25 watt bulb, shielding out all light except of that through the hole. While a real star serves best, this artificial star placed at one end of a basement is much more convenient. Your 2 inch camera lens, or a 5 to 10x magnifier, will serve to directly examine the image of this star at the focus of your lens (wide open at first). Tilt or swing the lens by the amount equal to that which would permit a line from the test star to go through the lens center and the corner of the size film holder planned. Re-examine the image with your magnifier. With most "fast" (large aperture ratio) lenses this view will present everything but a good star-like image—most likely a pear or flying seagull shape. Repeat these trials, stopping down the lens, one stop at a time. At a one stop closing with medium speed lenses (as $f/4.5$) or

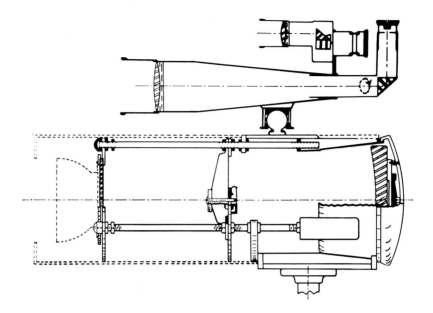

Figs. 25, 26. Design and construction of 5-in. aperture 10-in. F.L. f/2 Schmidt (less covering tube) with its 10° finder and 40X guide scope.

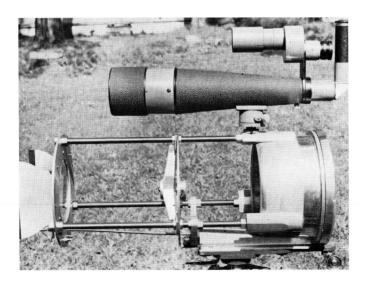

two stops with "fast" lenses ($f/1.4$ to $f/2.8$) a *marked* improvement in image quality will be noted, particularly with the off-axis image of the tilted lens. Appreciable improvement will continue for a stop or two more. These tests repeated with a ground glass of your photographic plate size in focal position (a bit more difficult to set up) provides even more useful information, particularly flatness, or lack of it, of the plane of best focus.

Experimenting in this simple way with various lenses, along with subsequent trial of the lenses, soon teaches one more about various lens aberrations than reading a dozen texts. Such experience allows rapid evaluation of lenses, reducing wasted time in temporary setups. Actually true lens bench testing is only a refinement of the above elementary, but very useful, lens testing method.

In using ordinary lenses, one soon learns that a happy (if possible) balance must be made between definition desired over a selected angle of view, and the light gathering capacity or aperture needed to do a job. Where long exposures are required patience may run out, particularly on cold nights, making one more interested in using the lens wide open and less critical of definition at plate corners.

Photographs of certain lenses referred to are presented here and where possible photographs taken with them are cross-referenced in this and following chapters. A word of caution—no lens should be assumed good until tested. Some large fast lenses produce horrible images in astro work, often only a few degrees away from the axis. Beware of most portrait lenses. The absence of a lens from our list does not necessarily mean it is bad—it may be less available, omitted to simplify, or unknown to us. Some lenses are very suitable for the purpose for which designed—but not for astrophotography. Where feasible, h.. older lenses coated.

Of the special lenses that have been designed and built for astrophotography the relatively simple Schmidt Camera (lens-mirror combination) yields finer definition over its entire field than any conventional photographic lens. Many amateur astronomers have now built their own and each is usually most pleasantly surprised at the unsurpassed definition and performance of such Schmidts. These are usually built in aperture ratios of $f/1.5$ to $f/3$.

A Schmidt camera is essentially a lens and camera all in

one, the lens part actually consisting of a thin especially surfaced lens in the front, pre-correcting light rays falling on a larger steeply curved spherical mirror in the rear. This in turn reflects light back to small circular convex film holder supported at a position between the lens and mirror. This is illustrated well in Figs. 25 and 26. The angle covered is comparatively small—being *about* 5 degrees in an $f/3$; 10 degrees in an $f/2$; and 15 degrees in $f/1.5$ or faster Schmidts —yet vastly larger than that of a parabolic mirror used for photography. Schmidts faster than $f/1.25$ are not worthwhile.

Let's take a look at the ordinary reflecting telescope with a parabolic mirror having perfect definition in the center of the field. As one moves away from the center, off axis definition falls off rapidly, limiting the most useful photographic field to *roughly* one inch in diameter in almost any sized reflector, or approximately one degree with the usual 6-inch $f/8$ mirror. While useless for general wide area photography, it is fortunately quite ample in many areas of narrow angle work as described in the next chapter.

The super fast ordinary lenses ($f/1.4$ to $f/2.0$) wide open suffer from a number of aberrations which in star work leads to images near the corners of the frame looking far more like flying seagulls than stars.

In 1930 Bernard Schmidt, by the sublimely simple means of introducing a thin complexly curved lens in front of a simply made spherical mirror, removed the problem of spherical aberration and in one swoop gave us an unexcelled star camera. This is attested to by the fact that a $f/2.0$ Schmidt can cover 10 degrees of angle from edge to edge with such definition as to produce sharp and perfectly round star images on the edge of a fine grain film even under a 20X magnifier— an unheard of feat at this aperture with ordinary lenses.

To describe how to make one is out of place here; however, a full description of how to build a Schmidt camera appears in *Amateur Telescope Making—Book Three* where details of the 5 inch $f/2.0$ Schmidt I designed and built (see Figs. 24, 25, 26) are presented. The "North American Nebula" photo (Fig. 108A) and several others I have reproduced in this book were taken with this Schmidt. An experimental 5 inch aperture $f/0.8$ Schmidt of 4 inch focus built was six times as fast as any $f/2.0$ lens and covered a 20 degree field quite well; however, it was too small, definition

Fig. 27. A very young inspector intently studies the groundglass of a giant surplus lens-camera combination of the type readily applied to astrophotography. Courtesy Walter N. Baer

suffered and sky fog was a problem. Such speeds are not recommended. If one must have a super fast Schmidt, an $f/1.5$ of 7 inch or 8 inch aperture covering a 15 degree field is much more practical. My recommendation for a single best "all around" size Schmidt is an $f/2.0$ with 7½ inch (from 8 inch plate) corrector plus a 10 inch mirror covering 10 degrees on a 2.6 inch circular film. The fine 7 inch aperture 16 inch focus ($f/2.2$) Schmidt by Bennett Sherman shown in Fig. 28 fits this specification. An $f/3.0$ of the same aperture covering 5 degrees, as Cooke's Schmidt, could be considered where smaller areas and greater magnification is desired—or where sky fog is a problem.

It's really best to build your own light-tight box on which to fasten a lens and plate (or film) holder. Most of the instruments illustrated were home built. Some amateurs, as Horace Dall, have even built their own small reflex camera units; however, most build the larger cameras and use commercial single lens reflex cameras or boxes for the smaller film sizes. Criterion markets one fitted for telescope use. Salvaging the plate holder "back" from an old camera can make this even easier. Many 4 x 5 old view cameras with large lens boards can be braced a bit (to maintain absolute infinity focus) and readily used. Complete war surplus cameras should be considered.

In making a box for a lens and plate holder it simplifies things if the plate holder as a unit can be adjusted with push-pull screws at the corners, to place the plate exactly at

right angles to the lens axis. Machine shop owners equipped for metal working can ignore this and "turn" to exactness. The lens could conveniently screw in and out for final adjustment. This latter feature is convenient even with the push-pull screw arrangement. There is little else to say. The illustrations already presented, plus "do-it-yourself" ingenuity, should be sufficient.

A silky fine ground glass for final focus adjustment is a help—provided it is not so fine that one's inspection magnifier focuses on the star image at points in front or behind the proper surface. If a star camera is really properly and substantially made and the same holder (or plate stops, or calibrated holders) is used no further adjustment should ever be needed. Because of maintenance of focal plane and the superior (for astrophotography) emulsions available from Kodak, plates are strongly recommended for sizes larger than 2¼ inches square.

We haven't mentioned shutters. Usually a lens cap, or your hat, will suffice with large lenses. The fancy shutter shown in Fig. 25 rates as my most useless accessory—never used. For short exposures some use a slot of a length somewhat greater than the lens diameter and about a tenth the lens width cut in cardboard (not too narrow) moved rapidly across the lens front—requires a bit of experimentation.

Sturdy tripods are a "must." Various wooden war surplus tripods in the ten dollar range are quite stable and can be readily adapted to support astronomical cameras. Edmund

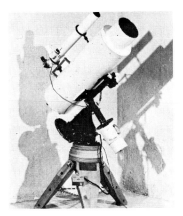

Fig. 28. An f/2.2 Schmidt camera 7-in. aperture, 16-in. focus, designed and built by Bennett Sherman. Has full electric controls and a really sturdy tripod.

Fig. 29. New SX-70 Polaroid mount for any scope. The easy way to color. Available through R.T. Little, 71 Willow St., Brooklyn, N.Y. 11201. (See *Astronomy*, Aug. 1975.) To order standard 35mm. attachments, contact Criterion, Edmund, Optica b/c, etc.

Scientific Co. supplies various suitable tripods. For lighter cameras Quick Set (a fine "small line" of tripods) and Davidson Star D tripods have worked well, the latter having a very rapid convenient leg locking device. Quite a sturdy type, yet light to carry, is the Majestic geared aluminum leg model—at low cost, considered a best all around value by myself and several others. In the really heavy duty professional types two good examples are the Quick Set Professional, which is remarkably light for its size, and the Linhof large professional models which are of outstanding quality, but very costly. Your photographic dealer will gladly show you more.

Fig. 29A. The variable power reflex camera adapter used to couple a camera to a 2- or 3-in. refracting lens equatorially mounted telescope makes an ideal beginner's photo unit. Courtesy Bushnell Optical Co.

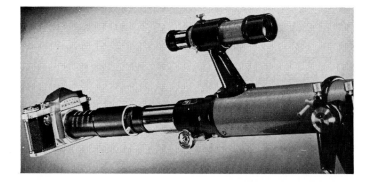

3

TELESCOPES, MOUNTINGS AND DRIVES

To move way out into space, photographically speaking, one needs longer focal lengths and larger lenses than those of the average camera. A telescope can be made to serve our need. Actually, any long focus lens is considered a *telescope* if fitted with an eyepiece to view the image; however, it is in turn a *camera* if provision is made to photograph rather than see the image. Figs. 30–32 show an instrument designed for photographing difficult distant objects along with two of its conquests in the hands of Dr. Custer. Actually much smaller instruments may do really worthwhile and interesting work. Any simple binocular, spotting scope, long focus lens, or refracting (or reflecting) telescope can be converted by coupling it to a light-tight box and film holder, or regular camera with or without its lens, to attack some phase of outer space photography where our photographic "reach" must be greatly extended.

Attachments are available to couple cameras to standard binoculars and the more common terrestrial and reflecting telescopes from Edmund, Criterion, Bausch and Lomb, Bushnell, Celestron, Meade, Optica b/c, Unitron and others.

A monocular or a spotting scope coupled to a 35 mm. camera with its normal 50 mm. lens, Fig. 34, serves as a 14 inch telephoto (telescopic) lens. The spotting scope of Fig. 33 with 20X eyepiece serves as a 40 inch telephoto or with 40X eyepiece as an 80 inch telephoto! The lunar photos on page 61

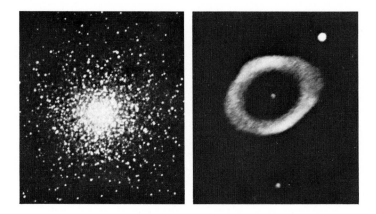

Figs. 30, 31, 32. A fine 101-in. focus, 12-in. aperture reflector astrographic tele-scope-camera with equatorial Springfield type mounting built by Clarence P. Custer, M.D. The globular star cluster M13 in Hercules and the ring nebula in Lyra are examples of work Dr. Custer has done with this equipment.

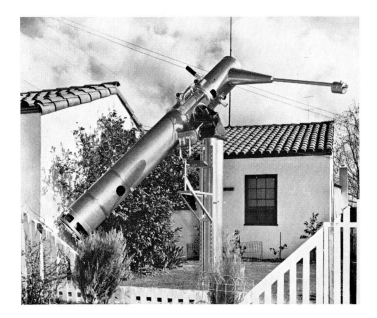

clearly illustrate such use. You may wish to couple an available long focus lens to your camera, making your own coupler —as shown in Figs. 35 to 37.

A piece of sturdy aluminum angle plus a slotted flat bar will serve to fasten most cameras to the side of a reflector telescope. Criterion makes a convenient "clamp on" model of coupler as shown in Fig. 38 to illustrate how couplers work, or you can use the more economical Edmund's coupler which requires drilling the tube for attachment. If you already own a telescope, check with your manufacturer for camera coupling attachments.

Larger lens (or mirror) diameters permit longer focal lengths with larger images, but above all permit greater definition or resolving power, as mentioned briefly below and illustrated in the last chapter on planets.

The race for larger photographic telescopes should nevertheless not inhibit one from using smaller equipment. In fact there are objects in the sky ideally suited in angular size for almost any instrument. The starting amateur should turn to these, reserving the difficult objects for future photographic adventures.

While a standard photographic lens of at least one inch aperture was recommended in the previous chapter, it is believed that a minimum of about 2 inches in aperture should be recommended when using long focus simple telescopes or telescopic lenses for astrophotography. Such lenses usually have a focal length of 20 to 30 inches, $f/10$ to $f/15$, providing considerable initial image magnification which can be increased by methods shown in Fig. 11, page 13. The 60 mm. diameter rifle range spotting scopes fall in this class as being very useful in both terrestrial and astronomical work.

What telescopes to consider for photographic use? A series of photographs of commercial instruments, other than a representative one or two, would serve little purpose since ads in *Sky and Telescope, Astronomy,* and *Modern Astronomy* can be more easily reviewed and literature is readily available.

Since a 3 inch refractor is probably the best all around size for the average amateur, Fig. 39 illustrates a 3 inch refractor with various accessories as manufactured by Unitron, a company which has been energetic in establishing, or re-establishing, the refractor in amateur work. Edmund Scientific Co. and others have very economical 3 inch equatorial

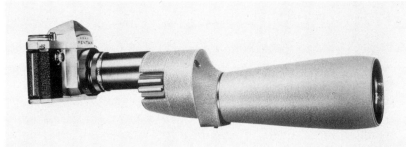

Fig. 33. Bushnell 60mm. Spacemaster II telescope with variable power reflex adapter. Courtesy Bushnell Optical Co.

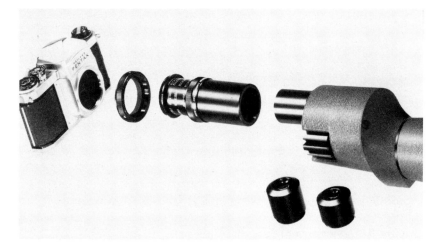

Fig. 34. The Bushnell Spacemaster variable power reflex camera coupling unit—disassembled. Courtesy Bushnell Optical Co.

Fig. 35. A 525mm. (approximately 20-in.), 80mm. aperture, long focus lens. Unit home assembled by Ralph Dakin.

refractors available. The Bausch and Lomb and Bushnell 60 mm. spotting scopes are the only ones of this class I've tried—both are excellent and of guaranteed performance. One should not leave this area of smaller instruments without mentioning an unusual jewel-like instrument, the Questar, Fig. 40, a 3½ inch aperture condensed optics system, permitting the utmost in convenience and portability. This instrument is ideal for many areas of amateur outer space and nature photography that fall within its light grasp. It might be compared in quality in the small telescope field to the Leica in the camera field (it's priced accordingly). For other refractors refer to manufacturers listed at the end of the book.

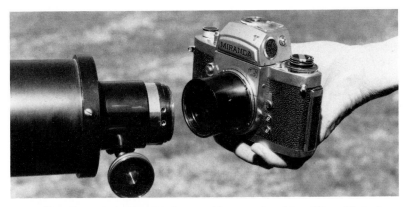

Fig. 36/37. The unit in Fig. 35 disassembles to take either 2X or 3X Barlows to increase focal lengths two or three times. Telephoto by Ralph Dakin.

Reflecting or mirror telescopes can readily be used with adapters. Criterion markets a superb 4-inch reflector. Edmund Scientific Co. also has small reflectors available. Instruments listed in *Sky and Telescope* magazine are generally reasonable values for the money invested. A 6-inch aperture $f/8$ is considered the best all around sized amateur reflector, with a trend toward an 8-inch $f/7$. Cave Optical Co. has for some time manufactured reliable 6-inch (and larger) reflectors of good substantial quality. Celestron has introduced 5-, 8-, 10-, and 14-inch "transportable" Schmidt-Cassegrainians. Criterion has a fine, similar 8-inch. Since its introduction of 1¼ inch axis shafts even 8-inch reflectors may be used. Excellent kits are available from Edmund, Optica b/c , and others.

These or similar instruments can serve as a sound founda-

tion on which to add slow motions, drives, etc., of your own design. Edmund now markets a very economical drive making it hardly worth the time to build your own. I am adapting a rather elegant, but most convenient drive, similar to Byers', or a Jaegers 6-in. *f*/10 home-built refractor for special work. Commercial siderial drives are now available on or off scopes. Once started and set to hour angle, they permit sighting on any object in the sky directly from the hour angle in an atlas —no fuss—no computations. If one has enough money, elaborate high quality instruments with drives and slow motions are available from suppliers—a partial listing of these appearing in the appendix. The author has no association with any organization mentioned and is only relating from his experience, as modified by that of his friends. Most comments are to illustrate a point of advantage.

Many amateurs build their own, and not only produce elegant instruments but do remarkable work with these— as established by photographic contributions to this volume. Details would be out of place here. *Amateur Telescope Making Books One, Two, and Three* should be consulted along with *Making Your Own Telescope* by Allyn Thompson. The excellent small British book *Frank's Book of the Telescope* $1.00 from Chas. Frank, Saltmarket, Glasgow, Scotland provides a mine of useful information written in an easily read manner that could only be based on thorough experience. These books have much of the detail you should have available for reference. The question of sizes, types, *f*/values, etc. of telescopes has been discussed elsewhere.

Equatorially mounted telescopes having a polar axis are

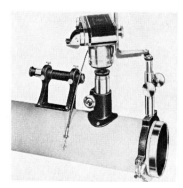

Fig. 38. A clamp-on unit to couple camera to a reflecting telescope, easy to attach and use. Courtesy Criterion Mfg. Co.

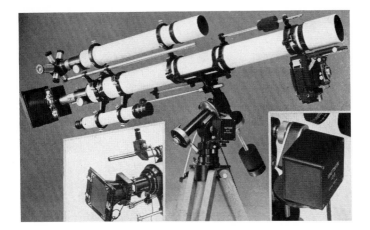

Fig. 39. A fine late model 3-in. equatorially mounted refractor with slow motions, star camera, guide scope and drive (see inserts). Courtesy Unitron.

the only mounts to consider for serious astrophotography. Russell Porter's diagram on page 7 should be studied again.

It is well, however, to be aware of the commonest types. Figure 41 was made to illustrate these. Just to be a little different, and totally impartial, antique instruments in good working order were selected as examples. The late 18th century metal mirror Gregorian (bottom) illustrates the so-called "pillar and claw" type of mounting—ball and socket or simple joint—none too good for most uses. At the right we have a rare Alvan Clark 3 inch aperture short focus $f/10$ refractor

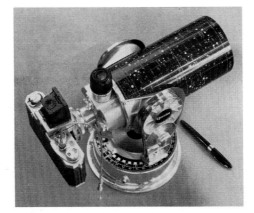

Fig. 40. An ultra-compact 45½-in. equivalent focus, 3½-in. aperture Questar lens-mirror telescope, the "Rolls-Royce" of small telescopes. Optically and mechanically perfect. Its compact size make it a traveler's dream.

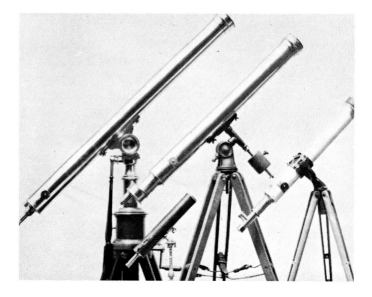

Fig. 41. A series of well preserved telescopes by early makers illustrating mountings.

with a simple alt-azimuth mount, having only horizontal and vertical motions. Such mounts, if sturdy, are very convenient for terrestrial and astronomical work with some ifs to consider; if limited to 3 or 4 inch aperture, if magnifications to be used are 150 or less, and if photographic work is limited to short exposures—tenths of seconds.

On the far left is a French Bardeau 4 inch alt-azimuth refractor from "the carriage days" with slow motion control handles and elevating post—a thing of beauty in brass and mahogany. Such slow motions are very handy on these for visual use, but not for photography.

In the center of this figure is shown a 3½ inch Alvan Clark $f/15$ refractor. Such an *equatorial* type mount, if fitted with a drive, is recommended for astrophotography. The polar axis, with a knob at the lower end, and the declination axis with its counter weight may be clearly seen.

For extended time exposures a drive to turn the polar axis at 1 RPD (one revolution per day) is essential. Russell Porter's informative sketch on page 7 should be reviewed again.

Two commercial drives have been mentioned. Most equipment manufacturers will supply such drives.

While ball (or roller) bearings in well designed mountings work smoothly, many experienced amateurs feel that mountings with plain, well-fitted bearings are the more stable—using an all-temperature lubricant and a drive motor of at least 10 watts. Shafts of most scopes could well be of larger diameter and hollow, for example 1¼ to 2 inch diameter with ¼ inch walls of aluminum or steel for 8 inch telescopes —other sizes accordingly. Stability can be greatly increased by widening the upper thrust end of the polar axis into flat disclike supporting surface areas of a diameter from that of the setting circles up to the scope tube diameter, as convenient units of measure. Somewhat smaller areas can profitably be used on the tube side of the declination axis.

The advantages in stability of such design, initiated years ago by Brashear (American) and Browning (English), have been repeatedly brought to the amateur instrument makers' attention by Alan Gee in a convincing manner. The amateur builder need not be inhibited by a slight increase of cost or labor. For other information on drives see A.T.M. Book 2, and literature from Byers, Meade, Unitron, Optica b/c and Edmund—beginners see their booklets by Sam Brown.

Some may wish to make their own drives. Fig. 42 shows an automatic sidereal time-keeping drive I constructed a few years ago. It is a good as any professional unit. It's been a pleasure to use. One simpler combination is a 4 RPH (1/15th RPM) synchronous motor coupled to a worm driving a standard 96 tooth worm gear turning the polar axis through a friction clutch. A slow motion may also work through a clutch arrangement where this drive couples to the worm—or mount the motor itself so it may be turned slowly back or ahead as a total unit to correct rate. Such gears and synchronous motors are available from Edmund and others.

Refractors of over 5 inch aperture and reflectors over 8 inches should have a fixed mounting and preferably be housed in an observatory. We often think of a rotating dome —quite an elegant but expensive method. A "tip off" cover often serves as a convenient substitute. For those who wish to build their own observatories, the roll-off roof types as constructed by many amateurs today and by the author (Fig. 44) seem to have a great many advantages indeed for

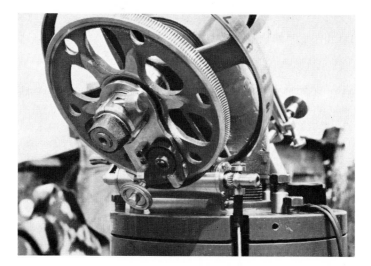

Fig. 42. Equatorial mount with sidereal drive, built by the author. Makes one revolution in 1436 minutes. See p. 334, Book 3, A.T.M.

their nominal cost. Mr. Keene has contributed greatly to the field of amateur astrophotography and presents much useful information in his book *Stargazing with Telescope and Camera*. A 12 foot side to side minimum is specifically recommended—certainly not less than 10 ft. Walter Semerau built a beautiful 10 ft. split roof type for his telescopes. He too urges that an ample size of the order recommended be considered right at the start—since his own equipment is rapidly outgrowing this building's modest dimensions. My 12 X 20 foot roll off roof observatory is fully described with illustrations in *Review of Popular Astronomy* issues of Dec. 1964-Jan. 1965 and Feb.-Mar. 1965. These issues are now out of print, so see your library. Many commercial domes are also available (See *Sky and Telescope*).

A brief review of the object-instrument reference table on page 103 is recommended before turning to specific areas of work.

Many hundreds of amateur observatories of countless designs have been built, with dozens of plans published in interim journals such as *Sky and Telescope*. Most writers tell how the observatories are built and point out their advantages. Quite

naturally, failures are seldom acknowledged. An important question is, "What would they do differently if they were to built a second observatory?" Since space permits only brief comments here, see the 1976 edition of *Telescopes for Skygazing* (Amphoto) for further information.

Above all, avoid mass (weight) called "heat sinks." Only a lucky few enjoy steady-temperature areas; most of us live in areas that have falling evening temperatures. Concrete or cinder-block walls and extended concrete floor aprons are definitely out. Simple observatories of marine plywood are very hard to beat. Seriously consider "roll offs" operating at ground level. Aluminum siding is good, and a fiberglass (white) or aluminum roof is fine. My "roll off," Fig. 43, was mechanically perfect but not suited for the climate. It took until 2:00 A.M. to cool off. This could have been avoided by running aluminum walls to the ground and rolling off at ground level—*no* concrete aprons. My Outer Space Observatory II, made of fiberglass and aluminum, has no heat problems and opens or closes in approximately 10 to 20 seconds.

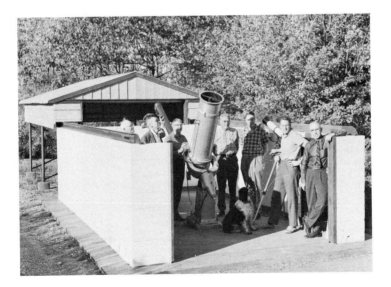

Fig. 43. Author's "Outer Space Observatory" with first observing group. L. to R., Paul W. Davis, Ed Lindberg, Jack Smith, Dr. John Cain, Ralph Dakin, George Keene, and the author. Several of these people made fine contributions to this book.

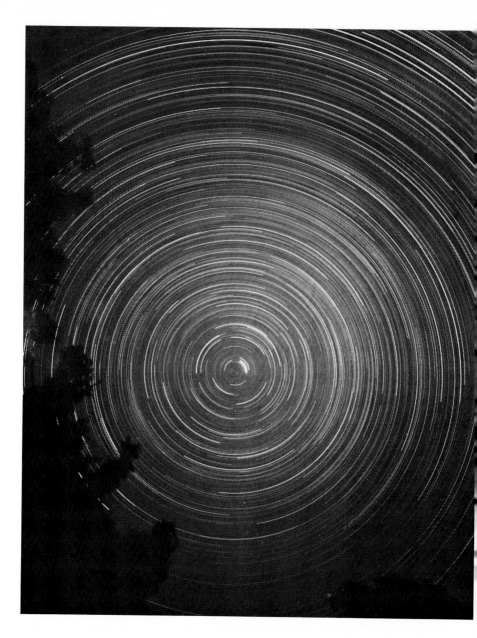

Fig. 45. Circumpolar star trail study. 4-hr. exposure, 127mm Kodak Ektar lens at f/4.7, Graphic camera. The eye can see only about 42 stars of the some 2000 shown. Note bright Polaris circling about 1° from the true pole. Photo by Paul W. Davis.

4

STAR TRAILS — A BEGINNING

Your home, church, or landscape can serve as a familiar silhouette background for a picturesque circumpolar star trail photograph of the type shown in Fig. 45 by Paul W. Davis. Such a photo in 16 x 20 or larger size can make a fine wall piece and will be admired by your friends interested in photography.

Star trails can serve very well for a photographer's first entry into outer space photography. Any equipment at hand plus a tripod can be used. Furthermore, many bits of information can be gained from star trail photography such as increased knowledge of star motion, camera functioning, lens errors, film characteristics, sky fog, etc.—all will be useful in later work.

To get started, take a few pictures. If you develop your own film (or own a Polaroid camera) then you can accomplish a lot in a short time. Set up your camera on a *steady* tripod and with the lens wide open and at infinity focus take a four minute (by your watch) time exposure with your camera centered on the North Star, also an equal exposure on another frame with the camera pointing approximately at the celestial ecliptic, i.e. roughly the path of the sun, moon and planets. During these four minutes the earth has turned one degree and all stars will have traveled a 360th of the way around their daily apparent path. After developing a film, use a hand lens of 1 or 2 inch focal length (your 50 mm. or

wide angle interchangeable camera lens can serve well here as a magnifier) and examine the negative against a diffused light. In this brief four minute period the motion of the stars on your equator shot will result in very apparent streaks (star trails) even with a 2 inch focal length lens, and much more so with long focus lenses. The circumpolar shot of the North Star area will show practically no motion at or near the Pole Star but will begin to show motion at the corners of the negative. If the camera is in focus a widening of the star trails at the corners of the negative is caused by off axis lens aberrations—a point to be discussed later. The trails on the equator shot give us another bit of information. These 1 degree long trails (less than 1/32nd inch! with a 2 inch focus lens) are still about twice the diameter that the sun or moon would have if you had photographed it with your regular camera—dramatically indicating the need for long focus lenses to move the image size of such objects up to the useful range.

Longer exposures will provide more information. Stopping your lens down about one full stop from its full aperture to improve definition, take three exposures of 20 minutes each (be sure the night is dark enough)—one facing the North Star and one on the equator as before and a third directly overhead, or to be more exact—in between the other two shots. Since the stars swing an apparent 15 degrees in an hour this will give 5 degree length star trails and much better illustrate apparent star motion with respect to the sky—and yet not try your patience with too long exposure times in first experiments.

Really photogenic star trail pictures, as Fig. 45, may take several hours—one to four anyway. Not only circumpolar, but even the almost straight equatorial star trails can be skillfully maneuvered into picturesque photographs as has been done in the beautiful photo of Orion by John Stofan, Fig. 46—a combination star and trail picture. With such long exposures new difficulties may arise. Sky light from city lights, moonlight, etc. can fog or blacken the film to the point of ruin. The simplest remedy is to stop the lens down until the length of exposure desired (to give adequate length of star trails) can be made without undue sky fogging of the film. A yellow filter can be used to cut out much stray scattered moonlight should a crescent moon be up, but sky

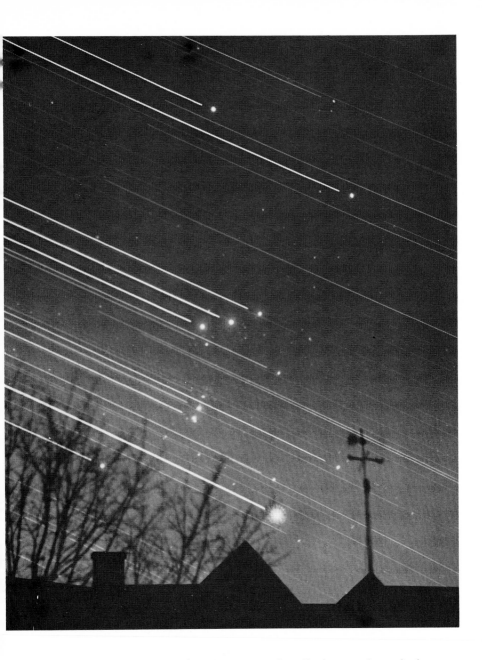

Fig. 46. Orion Trails, a combination star and trail photograph made by allowing the stars to trail for a couple of hours with the camera fixed, closing the shutter for 5 or 10 minutes, and making a final exposure of about a half hour with the camera driven to follow the stars. Panatomic X film. Photo by John Stofan.

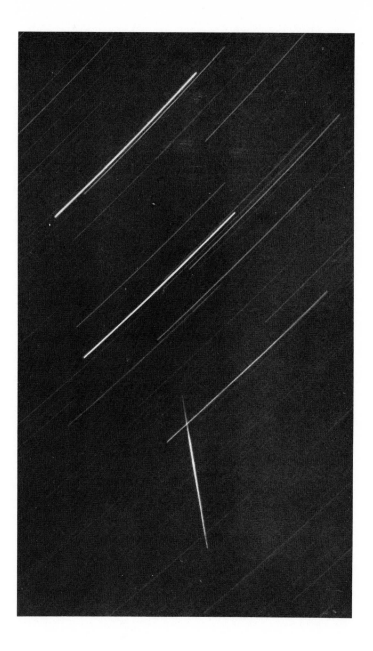

Fig. 47. Geminid meteor flashes below the star trails of Castor and Pollux, 10:45 P.M., Dec. 12, 1958. Kodak Medalist, f/3.5, medium speed film. By John T. Hopf, assisted by Robert Napier.

light from mixed mazda, neon and mercury lights is not so easily handled. The best remedy, of course, is a black night in a suitable location, i.e. away from auto lights, city lights, etc. Early hours of the morning have been used to some advantage by many astronomical photographers who have no choice of location.

Varying aperture, film, development, selecting lenses of different focal length, etc., can add much useful information. A "jog" in the trail at the beginning or end indicates shake of the camera in opening or closing of the shutter. A cable release is recommended but will not prevent shutter jar. Better yet, use a lens cap held in front of, but not touching, the lens during opening and closing of the lens. Any other unevenness of a smooth line would indicate camera motion —most likely from wind or bumping of too light a tripod. Interruptions of the smooth trail can be caused by clouds, tree branches, etc.—or dew condensing on your lens!

If one marks the beginning or end of a star trail photo with white dots of sizes in proportion to brightness of the star trails the constellations become apparent. Some may wish to calculate star *trail length* on film versus *time* for a given lens by using one of the following formulae where minutes and inches are the units of measure:

$$\text{Time} = \frac{\text{length desired} \times 229}{\text{lens focal length}}; \text{ or Length} = \frac{\text{time} \times \text{focal length}}{229}$$

Photographing star trails can be quite educational, with a good chance of obtaining really photogenic end products. Should a meteor streak through or burst in your camera's range, as it did for the Hopf-Napier team in Fig. 47, your photograph can be a contribution to science, particularly if you record the time and other data accompanying the event. Every amateur astronomer should obtain a copy of the fine book, *Starlight Nights*, by Leslie Peltier (Harper & Row), not for information on astrophotography or equipment, but for a most pleasurable accounting of another amateur's adventures in skygazing.

Fig. 48. Pioneer 11 as launched at Kennedy Space Center, Fla., April 1973, carrying 12 outboard instruments. It took striking color photos. (See color section.) Courtesy NASA.

5

HIGH FLYING OBJECTS —
PLANES, ROCKETS, AND SATELLITES

The photography of high flying objects certainly covers a multitude of things which fly, float or drift in or near our upper atmosphere. These range from ordinary high flying planes, rockets, and missiles, to enormous balloons, satellites, or even "space stations" soon to be working at highest possible altitudes (such stations can in turn take superior photographs of distant outer space objects practically unhampered by atmospheric interference). What a rocket looks like at lift-off is shown in Fig. 48.

In this work both still cameras and movie cameras can be effectively employed. Since it is impossible to cover each and every possible kind of object, it would seem much better to provide broad general information and trust to native ingenuity to apply this to the job at hand.

Let's first consider an area where our ordinary cameras without telelenses may be employed to advantage. One is satellite and rocket photography, since more and larger objects are constantly being added to those already steadily orbiting the earth every 90 minutes or so. Here our camera requirement is similar to that for meteor work. A lens of $f/4.5$ or faster speed is recommended plus the fastest available films. What may be photographed is shown by the work of others. In Fig. 50 Robert Cox captured two passes of Echo over the North Pole during a five hour exposure. Note circular motion of Polaris and meteor flash. Rocket cylin-

der cones often end-over-end flashing on and off like the taillight of an airplane. Mr. Feibelman recorded this in the rising Sputnik III rocket shown in Fig. 49. Information on the object's rate of travel can be gained by using a shutter rotating over the lens at a known speed, chopping the trail in known interval segments. Rocket launchings also make spectacular photos—particularly if in color. (See Figs. 48 and 51 and also color section.) The above areas of photography can be much fun for any amateur photographer using an ordinary camera.

Where still cameras are used with long focus lenses, experience tells us that the use of telephoto lenses on hand-held equipment should be limited to *about* 135 mm. focal length for 35 mm. cameras and in proportion for larger cameras. Certainly 200 mm. (about 8 inches) can well be placed as a reasonable upper practical limit. Gun stock and other types of shoulder supports can improve and extend telephoto use. Obviously a good panning head tripod would help even with these relatively shorter telephotos.

Using a standard reflex 35 mm. camera (or similar larger cameras) and a suitably proportioned sturdy pan head and tripod the sky is the limit for almost any focal length of telescopic or telephoto lens available. Figure 52 shows such a setup ready to go. See also Dallmeyer lens, page 24. Actually one of the most important factors, assuming a good lens and camera, is a smoothly operating pan head and a substantial tripod consistent with the focal length of the lens. For lenses 20 to 50 inches in focal length, heavy duty or so-called "professional tripods" should be used in all cases.

A few unusual "shots" may be of interest. The small cut of Fig. 54 is of a sounding balloon miles up in the sky (just a bright speck to the eye), photographed by Ralph Dakin who held a camera to the eyepiece of a large binocular for this picture.

When moon rocket Pioneer III was launched from Cape Canaveral on Dec. 6th, 1958, at 12:45.2 a.m., Mr. and Mrs. Ralph Davis were ready with two cameras 160 miles across the state to obtain the photos of Fig. 53. They captured the trail from about 2 minutes of the first stage's burning time using an ordinary 4 x 5 camera. With the long focus Questar camera they caught the last few seconds and burnout of the first stage as shown in the circular insert. I personally

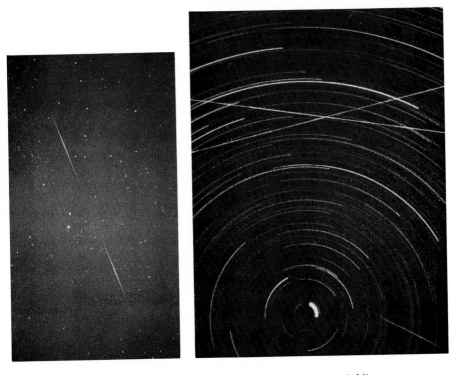

Figs. 49, 50. (left) Sputnik III rocket rising June 16, 1958. Folding camera, 120 size, Trioplan lens at f/2.9, Royal-X Pan. Photo by W. A. Feibelman. (right) Satellite Echo I crosses twice high in the sky while Polaris far below swings about the North Pole in an arc during the 5-hr. exposure. Note meteor flash lower right, 50mm Xenon at f/1.9, Tri-X film. By R. E. Cox.

saw a spectacular vapor halo with exhaust plume in the center from another firing while at Daytona Beach to the north.

Upper atmospheric haze often makes the addition of suitable filters a necessity. Usually a medium yellow (K-2) filter will do for most ordinary black and white film uses and a suitable haze or sky light filter for color photography. Such "optical quality" glass or glass "sandwich" filters for larger lenses can be quite costly. To reduce this cost gelatin film filters if carefully handled and protected can be used in front of the lens—or better yet as near the film as possible. Naturally the high optical quality (and expensive) glass filter as designed for use with a particular telephoto lens is ideal. In warning it should be stated that ordinary filters for normal lenses or odd "bargain" filters must not be used, since more often than not they will reduce or even ruin the fine optical

Fig. 51. An Air Force Titan 111-C lifting off from Cape Canaveral to launch Application Technology Satellite 6, the first in a new generation of NASA communication satellites. Courtesy NASA.

perfection and definition of your long focus telephoto or telescopic lens. Polarizing filters may be used to advantage in sky photography according to information readily available in photographic books. When used with focal lengths above 10 inches the quality of such filters must again be carefully considered or image definition will suffer.

Objects in the sky in daylight will be well illuminated as will sunlit objects high in the air after sunset or before sunrise. Exposure is a problem, with the best average guess being to use an exposure in the range which you would estimate for the object if it were nearby yet illuminated from the same direction. Trial and error will have to carry one from here.

Exposure times for stopping motion in rapidly moving objects should be as short as the lens opening and film speed will permit. The newer higher speed color films have a real advantage here over the slowest color films. For example, with an ASA 64 film and a camera attached to the usual long focus $f/15$ visual telescope (equivalent $f/16$ for practical purposes) one would have to use a shutter speed in the range of 1/50th second—too slow for many uses. An $f/8$ or

f/5.6 telephoto lens would permit an exposure of about 1/ 250th second. High Shutter speeds of 1/250th–1/1000th second are often desirable for stills. These later speeds can be readily used with any of the lenses described when films with an ASA rating in the range of 200 ars used. These recent new high speed color films certainly do remove one of the worst roadblocks of the past in the use of the usual long focus, relatively slow telescopic and telephoto lenses for color photography.

Most high flying objects are so far away that lenses will likely be used at the infinity setting and the reflex finder will

Fig. 52. The author with 30-in. focus f/10 Alvan Clark lens coupled to Contaflex camera for long distance work. You can build a 3″ or 4″ f/10 lens yourself.

serve mainly the important function of centering and following the object up to the instant of exposure. With very long focus lenses on relatively near objects, for example a rocket at and following takeoff, both focusing and centering will have to be done simultaneously in a continuous panning-focusing operation—one that admittedly requires some practice but which can become as much second nature as driving a car.

Having obtained suitable equipment and an opportunity to photograph an interesting upper air object the best way to start is to start—and see what comes out of the developer.

Certainly movies of rockets, missiles and fast planes, particularly in color, are exciting, and often newsworthy or of research value. Most of the still camera discussion of this chapter also applies to movies, and information that could be added is quite well known to the experienced amateur movie photographer. Again a smoothly operating and very sturdy pan head and tripod as indicated in Chapter 2 are all important. Modern high speed color film has automatically again solved the movie hobbyist's problems formerly encountered when working with the more economical $f/5.6$ to $f/16$ lenses most used in the very long focal lengths. Wherever possible, movie cameras using more than about 4X telephoto lenses should be of the beam splitting type to permit direct viewing, centering and focusing. A zoom lens plus a beam splitter makes a fine combination, particularly for rapidly moving objects near enough at times to require constant focusing.

While long focus lenses and massive tripods described do admirably serve their purpose, we should not forget that a normal movie camera speeded up to 24 frames/second used with 3X to 6X telephoto (or zoom) lens "on the scene" when a special event occurs is infinitely better than having special equipment which is not ready or "left at home." With such standard equipment many fine movies can be taken of the rapidly growing number of upper air space age objects. Specialized large equipment is usually best for specific pre-calculated assignments.

Fig. 53. (left) The moon rocket Pioneer III climbs into the sky over the Atlantic, with its final burnout plume. Photo by Ralph and Dorothy Davis.— Fig. 54. A sounding balloon miles up in the sky. Photo by Ralph Dakin.

6

PHOTOGRAPHING THE MOON

Although our nearby natural satellite is now the center of renewed attention and worldwide interest, photographers have been actively studying lunar surface details for a hundred and twenty years, since the first lunar photograph in 1840. Now as a result of space probing even the long hidden far side of the moon will soon become better known.

Because of the moon's brightness as a result of direct solar illumination and its *relatively* large angular size—compared to most celestial objects—our moon is an "easy" photographic object. Equipment can be quite simple but we must recognize that some sort of telephoto or telescopic lens is needed. Since the remark above about the relatively large size of the moon, while quite true, might be misleading to some, a few words of explanation are in order.

The moon's diameter expressed in the usual angular measure is only about one-half a degree or about the same apparent size as a quarter ten feet away! One's eye is easily deceived as to size, and a rising moon certainly looks larger than the values expressed. If you snap a photo of the full moon with the usual 50 mm. focal length lens the resulting image, less than one fiftieth of an inch on the film (if you can find it) makes one painfully aware of the acute need for some type of telephoto lens for lunar photography. Therefore, in photographing the moon the longest telephoto lens you have, or can easily commandeer, will probably not be too

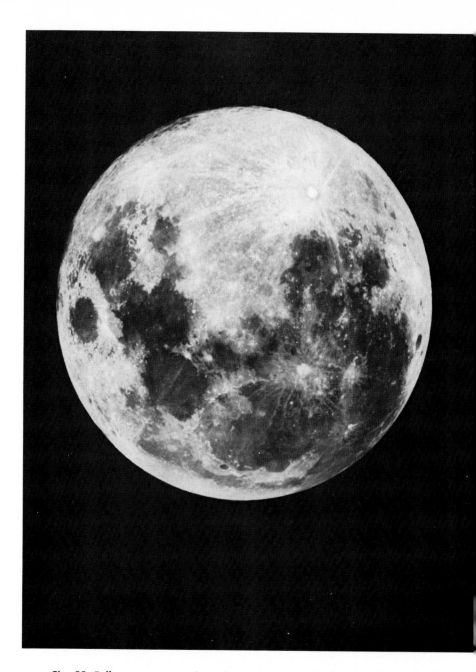

Fig. 55. Full moon as seen through an astronomical telescope. Photographed with homebuilt 10-in. aperture f/9 reflector scope, 0.8-in. image at prime focus. Contax camera. 1/25-sec. on slow (ASA 5) film, early Microfile. Developed in D-76 for twice normal time. Scope and photo by the author.

Fig. 56. First quarter—the moon approaching 8 days, a favorable observing time. Note marked areas for later closeups and the magnificent Apennine range below the lower marked area. Data as for full moon opposite except exposure time 1/5-sec. (Kodak High Contrast Copy Film—ASA 50) Photo by the author.

large. The image diameter of the moon, or sun, is approximately a hundredth of your lens focal length or more exactly divide focus by 115.

By using a single lens reflex 35 mm. camera with the usual 50 mm. lens working through a 7X binocular with a coupling attachment as described previously, the image size will be moved up to about an eighth of an inch. If fine grain film (as Kodak High Contrast Copy Film) is used the image can be enlarged 10-20X or to one to two inches in diameter. Such photos can be interesting, particularly when eclipses are covered, but hardly serve for wall hangings.

Any ordinary spotting scope, as used in rifle range target

Fig. 57. English stable yoke 10-in. aperture reflector plus Contax camera box which interchanged with ground glass and 10X magnifier. Built for lunar photography by the author.

spotting, along with a suitable coupler and the usual 20X eyepiece makes a much better combination with a 35 mm. reflex camera, the spotting scope serving as the equivalent of a 40 inch telescopic (or telephoto) lens providing us an image size of about .35 inch (almost ⅜ inch). If fine grain film is used this image can be enlarged to nicely fit into a good 8 x 10 enlargement with little loss of detail.

When a regular astronomical reflecting or refracting telescope of 30 inches or longer focal length (2 inch or more aperture) is available several schemes as described in the first chapter can be used to obtain almost any negative image size up to the film's limit in order to make later enlargements with little loss of detail. Each method has its advantages and these will be discussed later in order that you may select the one which most suits your available equipment or interests.

In using a long focus astronomical refractor lens in lunar black and white photography a yellow filter may be used as described elsewhere to minimize residual color error of such lenses.

Fig. 58. The Moon's image size at the focal plane of lens systems having increasing equivalent focal lengths—2X enlargements from Kodachromes by Ralph Dakin.

My first efforts at lunar photography were made with a simple reflecting telescope of 10 inch aperture and 90 inch focal length. I deliberately made the mirror this focal length (normal would be 80 inches or $f/8$) to obtain the image size I felt best for the 35 mm. camera. The eight-tenths inch image taken directly at focus on Microfile made into 10X enlargements produced spectacular 11 x 14 wall hangings which took a few prizes. Two of these pictures are reduced and reproduced in Figs. 55 and 56 (with the usual unavoidable loss of detail in copying, printing, etc.). This crude but effective telescope, built 20 years ago, was constructed in a few days from scrap lumber (the mirror took longer!) and was at once so successful that it encouraged far wider ventures into outer space photography. It is shown in Fig. 57.

Figure 58 presents a fine educational series of photographs contributed by Ralph Dakin. The copies shown (from Kodachromes) are reproduced as near to twice film scale as possible. This 35 mm. reflex series illustrates what can be expected from an unaided camera and with various tele lenses. The first of the series (a) is with a 50 mm. lens

61

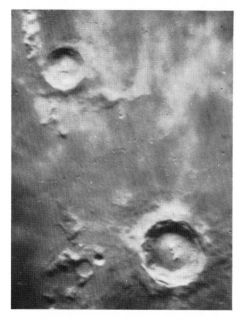

Fig. 59. The Copernicus and Eratosthenes area. Microfile film, with Questar scope. By Ralph and Dorothy Davis.

Fig. 60. Craters Alphonsus (top) and Ptolemaeus (bottom). 15½-in. aperture Cassegrainian scope with amplifier lens for E.F.L. of 1120-in. By Horace Dall, England.

Fig. 62. Clavius and surroundings. Homebuilt Newtonian f/5 reflector, 7mm eyepiece; image projected on Royal Pan film, 1 sec. exposure, DK-60A developer. Instrument and photo by Dr. S. R. B. Cooke.

Fig. 61. Triesnecker and its system of trenchlike clefts. Data as for Fig. 60. By Horace Dall, England.

alone. The next (b) was taken with the 50 mm. lens removed and the film directly at the focus of a 420 mm. or 16½ inch telephoto lens (see page 36 for equipment used). The last two photos (c and d) were taken with the 35 mm. reflex camera and lens coupled to a Bausch and Lomb spotting scope working through the 15X eyepiece in the first case and the 20X in the second. These last two setups give the same respective image sizes as if 30 inch or 40 inch telephoto or telescopic lenses were used coupled directly to camera less lens. Note the versatile Bushnell units on page 36.

The last three amplifying "setups" of Fig. 11, page 13, are very satisfactory for "closeups" of the moon's surface where considerable enlargement of the image is desired and only a portion falls on the film—which in turn may again be enlarged in final printing.

It is always a pleasure to see outstanding accomplishments of other amateur photographers working in one's own area of interest. The lunar "closeup" in Fig. 59 is the result of a combination of the outstanding skill of Ralph and Dorothy F. Davis of Florida and an exceptionally fine "all purpose" visual-photographic telescope (the portable ultra compact 3½ inch aperture Questar, designed by Lawrence Bramer of the Questar Corporation, New Hope, Pa.). Such a photograph would be considered very good if taken with an 8 to 12 inch aperture instrument, but was taken with a 3½ inch aperture! The left margin should be the bottom for proper viewing. Printed to full scale the original 8 x 10 would stretch to almost a 30 inch diameter moon. Note the wealth of tiny craterlets between Copernicus and Eratosthenes and the Copernican rays shown in sharp contrast in smaller scale in the full moon of Fig. 55 in the lower right quadrant.

The fine high resolution photograph Fig. 60 of Alphonsus (top) and Ptolemäus (bottom) was contributed by Horace Dall of Luton, England, and in the original 4 x 5 print was to a scale of about 30 miles per inch. The entire moon to this scale would make a "mural" over 5 ft. in diameter. This area may be located in the first quarter photo of Fig. 56 in the central area indicated. Figure 61 should be rotated 45 degrees clockwise for viewing. Note the intricate cleft system to the left of Triesnecker. In the deepening shadow below is the more prominent Hyginus rill with its central crater interruption. Gilbert Fielder of England most ably reviews

such features in the April 1960 issue of *Sky and Telescope,* page 334. This area is outlined below center in our quarter moon picture. These intimate lunar scenes were taken with a 15 inch aperture reflector using a positive lens amplifier as shown in Fig. 11, page 13 to enlarge the image on the 35 mm. film equivalent to that from a telescope of 1120 inches (over 90 ft.) focal length. Mr. Dall feels that "close-ups" of lunar surface detail can offer a challenge for high resolution work. Here the amateur can compete with the large instruments because of his flexibility of action—seizing moments of "good seeing" and proper lunar landscape illumination—while the large instruments may be tied up with other jobs. Dr. S. R. B. Cooke in Fig. 62 presents a detailed photo of Clavius (top) and Maginus (bottom). The interesting crescent of craters within the main crater are conspicuous. This area is marked near the top of our quarter moon picture. Here Maginus can be seen but only the left plateau of Clavius shows, the sunlight not yet having reached the deep floor of this huge crater.

I'd recommend Kodak High Contrast Copy for full moon pictures with doubled development in D-76. For photographs of other phases one can move to Panatomic-X and wider latitude films for crescent stages. For closeup work choice depends on initial definition desired and contrast in the area studied. The best broad information on exposure is that if we use a factor of 1 for the full moon, then about 4 times this exposure will be required for quarters and about 10 times or so for crescents. As a starting point on the quarter moon at $f/8$ try 1/50th second on Panatomic-X film.

Kodak Microfile film is now officially listed as Kodak High Contrast Copy Film and the speed has been increased some ten fold—so shorten exposures presented accordingly for even sharper images, as noted previously.

Write to *Sky and Telescope* for available lunar maps and to NASA (Audio-Visual Dept., Washington, D.C.) for lunar, rocket, and planetary photos.

7

PHOTOGRAPHING THE SUN

Danger seems an odd word to introduce such a seemingly innocent hobby as photography of the sun. Nevertheless *now* is the time to caution against looking at the sun through any kind of optical light gathering instrument, or even the naked eye, without adequate precautionary measures. **Permanent injury to your eye in the form of at least partial blindness can occur from sunlight concentrated to burning strength in a lens system.** One should also be on constant guard to protect uninitiated friends—don't forget the finder on your telescope—cap and seal it. Above all watch out for children who will try to look through anything.

An easy way to view the sun is to use the projection system essentially identical to that shown in Fig. 11c, page 13, except a white screen replaces the film and is usually placed at an increased distance behind and perpendicular to the scope's axis to obtain a suitably large image for viewing. By placing a camera to one side of the eyepiece the solar image on the white screen may be photographed—but not easily without extensive shielding. A light meter may be used as a guide here.

Our most important problem in direct solar photography is reducing the sun's intensity several thousand fold—usually from ten thousand to a hundred thousand times. A direct image of the sun can burn out a cloth focal plane shutter in a hurry—let alone the film. There are many ways of reducing

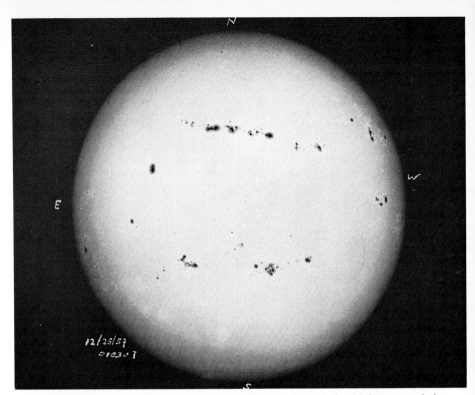

Fig. 63. Sunspot maximum, Dec. 25, 1957, the day of the highest recorded sunspot number. Photographed through a 6-in. Unitron refractor by Hans Arber, Philippines.—Fig. 64, (below) Gigantic sunspot area photographed through a Questar scope by Ralph and Dorothy Davis. Note 1″ granules.

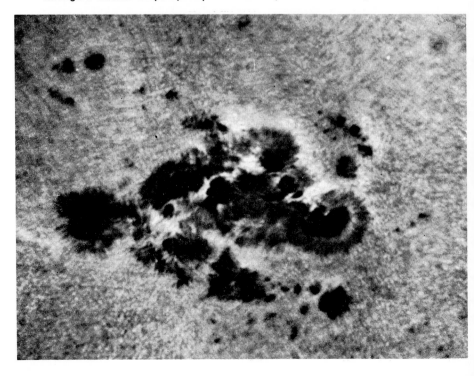

light intensity, such as use of a Herschel wedge, unsilvered mirrors, reduction of aperture (with loss of definition), etc. These are clearly illustrated in *Astronomical Photography at the Telescope* by T. Rackham. I would like to recommend *one* specific easy way to start and leave other methods to the reader to investigate at leisure.

Inexpensive neutral density gelatin films may be purchased from your photo dealer. Obtain these in squares large enough to cover the objective lens being used, although a 3 inch is large enough in most instances. Use with 6 inch or larger mirror telescopes and lenses by reducing to this aperture. Obtain one each of densities (D) 1.0, 2.0 and 4.0 of these inexpensive filters. These may be added together for other densities. D3 reduces the light a thousand, D4 ten thousand, D5 one hundred thousand times.

Handle or fasten such filters only by unused corners or edges—do not touch surfaces being used. With the density 5.0 filter (D1 + D4) in front of lens (be sure lens is covered at *all* other times) take a series of exposures with your favorite black and white (or color) film at 1/25th second, and alternate higher speeds. When your camera is coupled to a telescope the diaphragm is usually kept at full opening with the telescope itself limiting the f/value from f/15 to f/60 depending on your setup. On ordinary cameras use stops from f/11 to f/22. Keep a record. After developing, inspect negatives to see where you are as to desired image density, sunspot detail, or whatever you want. If negative is too light (not exposed enough—very slow film or long focus small aperture systems) cut to filter D4; or if too dark (overexposed—fast film) go to density 6 by adding D2 + D4. You should now have your set up in order for solar photography, assuming focus and other factors were correct. Such experimenting is best, since it is impossible to recommend a fixed exposure for varied cameras, films, telescope setups, and atmospheric conditions. As a single "guestimate" try Verichrome Pan, or a similar film, plus Density 5 filter— 1/60th at f/11 as your baseline—you may be near. The Kodak free booklet *Solar Eclipse Photography* contains added useful information.

Once you have solved the illumination problem for your film and equipment, much of the information in the previous chapters can apply here. We have spoken so often about fast

films that it's almost strange to "about face" and recommend for solar work just the opposite, the slowest panchromatic emulsions—or even lantern slide plates. The best atmospheric conditions for solar photography are usually in the morning before the ground heats up to cause air current disturbances. Often a clearing following a cloudy period offers an excellent opportunity.

My own first solar photographs were taken with a Contax camera plus a 135 mm. ƒ/4 Sonnar telephoto. The image was too small to be useful, except for eclipse photography as described in the next chapter. For general solar photography a telephoto or telescope lens arranged to produce at least a 40 inch equivalent focal length is recommended. A 20X rifle range spotting scope as described in the previous chapter for lunar work coupled to a regular 35 mm. camera, lens and all, meets this minimum requirement. Thus at least a ⅓ inch image size will be available. An equivalent focal length of from roughly 40 to 90 inches is certainly better for a 35 mm. camera box permitting the full image of the sun within the frame, with about a millimeter to spare on each side with the 90 inch focus. By use of projection means as described on page 65, any image size desired can be had with the film covering that portion of the sun desired.

Let's turn to the outstanding work of some amateurs interested in solar photography. Hans Arber of the Philippines in Fig. 63 (top) photographed the sun on the day of the highest sunspot number ever recorded. The magnificent "closeup" of a gigantic single sunspot area in Fig. 64 (bottom) is evidence again of the exacting work of Ralph and Dorothy Davis of Florida, using the 3½ inch aperture Questar described elsewhere. Note "rice grain" texture.

Every once in a while a series of photographs in sequence is both striking and informative. Such is the case in the thorough research done in Florida by Matt F. Taggart. Shown above are selections from the photos he presented to me, consisting of a fine series of eleven beautiful full color

68

3 x 4 prints covering from dawn breaking to completed sunrise. These show many unusual low horizon phenomena including one shown in the fourth photo of the series called "fish-bowling" (invert and view). The elliptical phase of sunrise is beautifully shown in the first photo. In the original color series the fifth photo looks just like an atom bomb explosion. The inferior image—or mirage—was caused by a temperature difference of 28 degrees between the atmosphere and the warm air hugging the ocean.

Those who have viewed the solar prominences through a prominence telescope need not be told of the awesome feeling induced by these intense red flames suddenly shooting up millions of miles, to often fall back in graceful arcs to the seething solar surface. Josef Klepesta in Czechoslovakia on April 11th, 1959, captured the gigantic eruptive prominence shown in two stages in Fig. 68. This arched at a speed of 300 miles per second to a height of 224,000 miles with gaseous remnants moving on up to a half million miles. Such majestic events may be readily photographed in color if one has a suitable instrument to isolate the hydrogen light (a rather big "if"). One needs an extremely narrow cutting filter —about four Angstroms in width. In *Amateur Telescope Making Book Three* I have described in detail the making of such a filter—a combination Quartz-Polaroid type to isolate the region of the H-alpha or hydrogen spectral line. One of these has been supplied to the Franklin Institute at Philadelphia which is open for public viewing. Some time ago I helped Walter Semerau initiate a filter, passing along some of David Warshaw's techniques. As is often pleasantly the case, the pupil soon outstripped the teacher as was the case with his prominence photography. Figure 67 is a composite of a few of Mr. Semerau's black and white photographs covering interesting prominence activity. Note the return arch in one of the figures and the two brilliant jets in another. His time lapse movies of solar activity at the sun's edge are extremely colorful and striking.

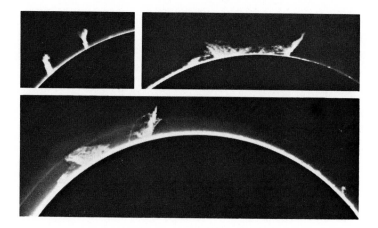

Fig. 67. Solar prominences as photographed by Walter J. Semerau. (See color section for striking solar photos.)

Fig. 68. Giant eruptive solar prominence photographed in red hydrogen light with 6.3-in. aperture f/18.5 Coronograph working through a 5 Angstrom quartz monochromator. Photos by Josef Klepesta, Czechoslovakia.

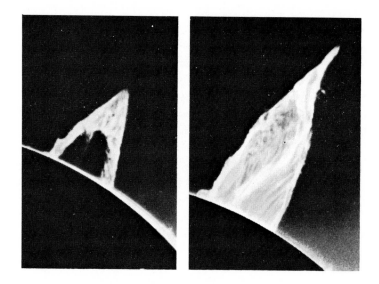

8

ECLIPSE PHOTOGRAPHY

This section will primarily be devoted to showing what has been done photographically in solar and lunar eclipse work, since the previous chapter may be applied in all except total, or near total, phases of an eclipse.

SOLAR ECLIPSES

Very interesting eclipse photographs can be taken with ordinary cameras having standard focal length lenses, particularly at totality. These are as striking to most people as any in the astronomical area. This is particularly true where the flaming corona extends millions of miles out into space. Shorter exposures during totality often clearly show the bright red prominences protruding beyond the moon's shielding disc.

You should wherever possible make some tests in advance with your film and equipment (even if not "on location") as outlined in the previous chapter. All of this will apply except for the final or totality phase where others' experience can guide. Kodak now has a small brochure available from your dealer entitled, *Solar Eclipse Photography for the Amateur*. It contains much good information.

Should no advance information be available at eclipse time the following is offered. For cameras with no adjustments using Verichrome Pan film (now ASA 125) try an estimated

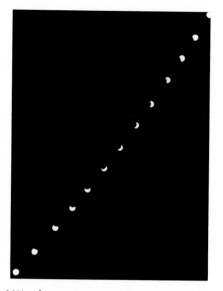

Fig. 69. (above) 64% obscuration partial eclipse at 10 minute intervals. 3¼ x 4¼ Speed Graphic, 170mm Kodak Anastigmat, 1/400-sec. at f/22 Eastman Contrast Process Pan, using Wratten A plus 5% transmission ND filters. By the author.—Fig. 70. (below, left) Partial solar eclipse plus large sunspot grouping, by Paul W. Davis.—Fig. 71. (below, right) Eclipse photographed as projected on a bedroom wall, by Ramon E. Massot.

1 to 2 second time exposure at the moment of totality. At all other phases a dense neutral filter, such as density number 5 (D1 + D4), should be over the lens and instantaneous speed used. For shutter cameras with stops using Verichrome Pan film and density No. 5 filter, fix aperture at $f/11$ and use 1/60 (or 1/50) second for partial phases. At totality remove filter and use 1/30th (or 1/25th) for prominences, and one second with the lens wide open for the corona—if no slow speeds, set on time or bulb and estimate 1 to 3 seconds' exposure.

As regards films, we have an area here where the finer grained slower films as Panatomic X, Plus X, and Verichrome Pan are ideally suited for partial phases while high speed panchromatic films are often used for outer corona work. For true amateur work covering all phases perhaps the always available Verichrome Pan may well be a good all-around film—hence it has been used as a baseline.

Partial eclipses are considered by many as not being very spectacular or photogenic. To an extent this may be true, yet the photographs shown opposite are both unusual and interesting. At the lower left we have a partial eclipse photo by Paul W. Davis with huge sunspots and limb darkening. Through the center is a 13-exposure 10-minute interval sequence of an entire partial eclipse taken with my Speed Graphic camera. R. E. Massot on July 9, 1945, projected a 6 foot image of the sun from his 6-inch aperture $f/9$ reflector directly onto the wall for a very unusual photograph. Paul W. Davis (Fig. 75) succeeded in catching the moon "taking a last minute bite out of the sun," just as it was sinking behind the distant tree branches and clouds. He arrived home with only a minute or two left to "ready" his equipment—punched ¼ inch aperture stop hole in cardboard with a stick and caught this moment.

In total eclipses we have many interesting phases. Just before the sun is totally covered, or just after it emerges, there is the beautiful effect known as "the diamond ring" as shown in Roland Rustad Jr's photograph, Fig. 74. Note the small prominence at the 5 o'clock position.

It is at a total solar eclipse that we see nature stage an infrequent but most glorious show with its many phases, from the diamond ring through Baily's beads to the tremendous spectacle of the flaming prominences and coronal halo.

73

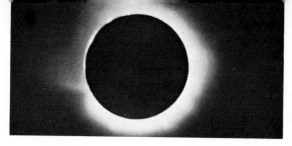

Fig. 73. Questar telescope, Leica, Visoflex II, by Dumont Rush.

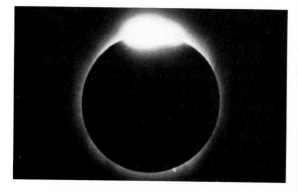

Fig. 74. 3-in. aperture 40-in. focus refractor (f/13.3) 1/25-sec., Pana-tomic-X, developed in D-76. By Roland Rustad, Jr.

Fig. 75. Taken with 75-in. focus refractor, 1/500-sec. at about f/200 (small hole punched in cardboard over lens). Plus X. By Paul W. Davis

Fig. 72. Lunar eclipse under the Pleiades, 10-in. focus lens on 35mm camera. By Alan McClure.

Fig. 76. The Moon's shadow cone reaching down to the earth is perfectly shown in this photo of the October 2, 1959 total eclipse. Taken at 21,000-ft. from plane 16 miles off the Massachusetts coast by Edward F. Carr, courtesy of Boston Globe.

In Fig. 73 Dumont Rush has captured both the inner corona and prominence activity. For outer corona see page 4.

LUNAR ECLIPSES

These are much more common but usually not as spectacular. I have seen some deep reds near the maximum phases which are beautiful visually and photographically— when color film is used. Paul W. Davis presents a picturesque composite view of a lunar eclipse over the Rochester University campus in Fig. 77. Alan McClure in Fig. 72 presents a partially eclipsed moon hanging like a pendulum under the Pleiades. Time lapse color movies using fast films offer promise for recording of a lunar eclipse in colorful action.

Fig. 77. Lunar eclipse sequence: 36-in. focus f/6.3 Dallmeyer lens at f/8, Exakta camera at prime focus. Plus-X film. University of Rochester photo blended in. By Paul W. Davis.

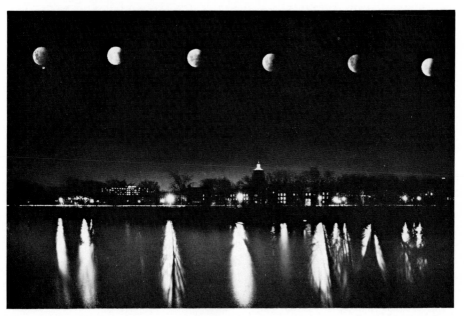

9

PHOTOGRAPHING THE STARS

A new era is now open to those starting astrophotography by the advent of ASA 1000+ films—one that is interesting, simple and easy. The constellations can now be photographed in a matter of seconds without a driven mounting by any amateur photographer. This is quite a change since the first photograph of a star was taken in America in 1850. Any camera with an $f/4.5$ or faster lens 1 inch in diameter plus a fast film, as Kodak's Royal-X Pan or other 1000 ASA speed range film, thus permits direct excellent star filled constellation photographs using a few seconds exposure— too short to permit undesirable star motion on the film— hence no driven mounting or special equipment is required. I took the pictures in Figs. 78, 79 and 80 one evening early in Spring using a Polaroid camera (110A with 5 inch $f/4.7$ lens) with its 3000 speed Type 47 film just to illustrate what could be done. (Reported in detail in *Modern Photography,* September 1960.) Simple calculation tells us that for this focal length lens a ten second exposure of equatorial stars does not permit star image movement on the film to reach one three-hundredth of an inch—a tolerated amount as may be noted from the figures. Ralph Dakin points out that to calculate the maximum star image motion on the film *per second* of time multiply 0.00007 x lens focal length in inches —watch out for decimal point! For example maximum image motion *per second* for a 14 inch lens is about one thou-

Fig. 78. (top) Star motion illustrated: to the left, 30-sec.; to the right, 2-min. Polaroid Type 47 film.—Fig. 79. (center) Orion in winter. Small arrow indicates the nebula. 10-sec. at f/4.7, Polaroid Type 47 film.—Fig. 80. (below) Big Dipper in Ursa Major. 30-sec. exposure. Note twin stars in bend of handle. See text. Photos by the author.

Figs. 81, 82, 83. The Pleiades as they appear photographed by lenses of increasing focal lengths. (left) 10-sec. on Polaroid Type 47 film, f/4.7, 110A Polaroid Land Camera. (center) Contax, Zeiss Sonnar f/2.8, Panatomic-X, 2-min. exposure. By the author. (right) Schmidt camera, Super-XX film, 45-min. at f/3.1. By. Dr. S. R. B. Cooke.

sandth of an inch. A good film can resolve this; however, we can often allow about 3 times this motion without noticing it in unenlarged pictures—as I did in permitting 3.5 thousandths of a inch motion in 10 seconds with the 5 inch focus Polaroid lens described. Proportionately longer exposure may be used for shorter focal length lenses and conversely shorter exposures for the longer focal lengths. The exposure time for a given lens may also be increased up to about 3 times, as we move into the reduced star motion of the Polar area—see Fig. 80. Doubling the regular Polaroid developing time for better contrast is recommended, *after* the camera is brought inside to room temperature when nights are cold. Ralph Dakin states that by using modern ASA 160 color film you can record in ten seconds all the stars you can see, using a 35 mm. camera with an f/2 lens. It is better to use an f/1.4 lens than to push film development.

Normally, star photography is more neatly done by having the photographic apparatus on a mounting driven to follow the stars as described in Chapter 3, a guiding telescope correcting various errors for long exposure; hence it's time for a word about *guiding,* since prolonged exposures usually require such control over and above our telescope drive.

A guiding telescope separate from our camera is most commonly used. Broadly speaking, the longer its focal length is with respect to our photographic lens the better, reducing on the film any errors we make guiding. Some quite satisfactory star photographs were made by fastening a 4 x 5 Speed Graphic on the side of the crude 90 inch focus telescope shown on page 60. A crossed thread at the eyepiece focus was centered on an out of focus image of a bright star and from a seat on top of a step ladder the unit was moved with care by hand to follow stars for up to 30 minutes—no

clock drive or slow motion of any kind. Therefore the R.A. slow motion control of a non-driven telescope may be continuously turned by hand as a drive substitute for limited exposures, correcting declination only if necessary. This works best when cameras have focal lengths considerably less than the guide telescope used.

A guide scope needs reference point at the focal plane of the eyepiece to coincide with its image plane. For large guide scopes a fine crossed thread will do—silhouetted against an out of focus star image. A single silk thread (from an old tie) works well as does engraved reticules from war surplus supply. For really fine work diamond engraved—not etched—should be used. A small bulb controlled by rheostat can serve to illuminate the cross hair or reticule from the side—a quite worthwhile addition. Edmund Scientific Co. now has these as surplus items in battery operated units, including a flexible fiberglass tube penlight.

There are unlimited variations in guiding methods and equipment as the need varies. The guide scope should always have an equivalent focal length equal to that of the photo lens and preferably two to four times this. Very fine cross hairs and high power eyepieces can make up somewhat for shorter focal length guide scopes. Besides being sure the cross hair stays centered on the star, be sure the focal planes of the eyepiece and image coincide—shift the eye from side to side—the relation of cross hair (if at true focus) to star image should *not* shift!

Figs. 84, 85, 86. (left) 25° strip of southern Milky Way centering on R.A. 17 hrs., 55 min. Dec. S-22°. 45-min. exposure at f/4 on Eastman 103aC emulsion. (center) Star clouds of Saggitarius, with 20-in. F. L. Goto (Tessar type) lens at f/6.3. 25-min. on 103a-E plus 23A filter. Photo Alan McClure. (right) The Trifid and Lagoon nebulae; 10-in. F.L. f/2 Schmidt. 15-min. on 103a-E film. Photo by the author.

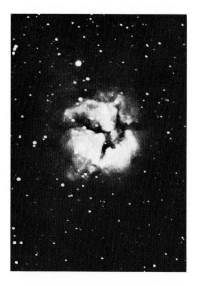

Fig. 87. The Trifid nebula, M20 Sagit through 20-in. aperture f/6 reflector. 1½-hrs. on 103a-E plate through Wratten 29 (red) filter. By E. C. Silva, Portugal.—Fig. 88. (below) The Lagoon nebula, M8 Sagit. Data as for previous picture.

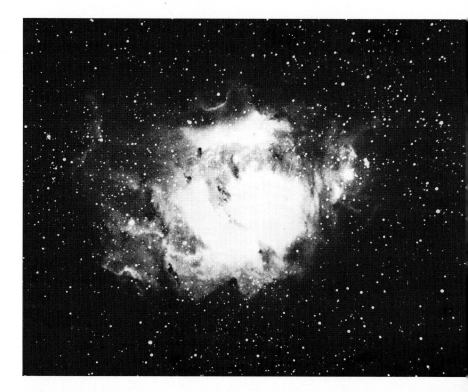

Fig. 89, 90. The Veil Nebula of Cygnus. (above) 3X enlargement from 10-in. F.L. f/2 Schmidt. 15-min. on 103aE. By the author. (below) Detail of filamentous veil, 120-in. F. L. f/6 reflector; 1½-hrs. on 103aO. By E. C. Silva.

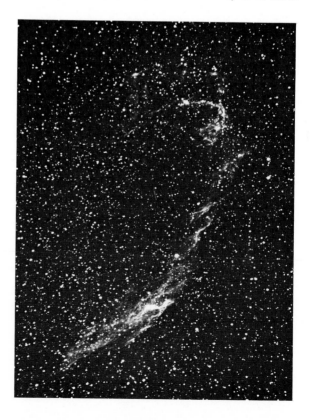

In Chapter 1 we mentioned the value of large apertures. In photography of faint stars such larger apertures have distinct value. Longer focal lengths and greater aperture also permit better separation of stars in star cluster photography soon to be discussed. These are some of the reasons for the constant desire for larger lenses. One possible negative consideration I've observed, besides cost, which is often neglected is that very large equipment often becomes a "white elephant"—just too much trouble to set up to use. Reasonable portability is a true asset.

GENERAL STAR PHOTOGRAPHY

In general star work we think of photographing wide areas, including true wide angle lens work. Ordinary lenses cover about 50 degrees of angle and the average truly wide angle lens about 90 degrees. For critical astro work one most often has to use less than a lens's rated angle, and in larger lenses seldom can more than a 4 x 5 plate be used, regardless of size.

Let's start with wide angle work first and move to narrower angles of coverage in later discussions of more restricted areas in the sky. After trying and trading a number of wide angle lenses I settled on a 6-inch Bausch and Lomb $f/6.3$ Metrogon stopped down a half stop to $f/8$ to markedly improve definition at the edge of the field (lens bench check also confirmed this). This lens proved very fine for the simple reason that its main residual optical error is a trace of astigmatism, an error producing a cross-like effect on a star image, rather than the tailed comatic or spherical observation image formed by most lenses. This cross ("star like" to many) is not at all unpleasing to the eye and is similar to that produced in large observatory photos by the four camera supporting arms in large instruments and which most of us are accustomed to seeing.

Figure 17 on page 18 is a long exposure of our southern Milky Way taken with this lens attached to a box I built to take a regular 8 x 10 plate holders for using Eastman Kodak 103aE spectroscopic plates (as shown in Fig. 18, page 20) —top to bottom of this photo represents some 50 degrees of sky angle. The Perseid meteor flashing down the Milky Way is shown in detail in Fig. 126, page 106. The Ross

82

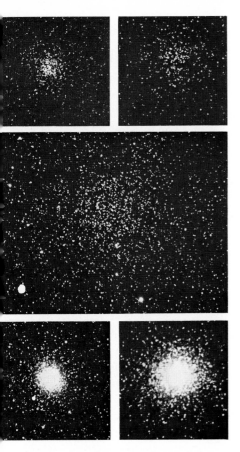

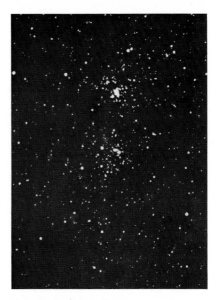

Fig. 92. Galactic cluster h and Chi Persei. 15-min. at f/2 on Eastman Contrast Process Pan, developed in D-19. 5-in. aperture 10-in. F. L. Schmidt camera. By the author. This is commonly known as the "double cluster" in Perseus.

Fig. 91. (top left) M11 Scuti. 5-min. on Superpan-Press, dev. D-19. 12½-in. aperture Newtonian f/5. By Dr. S. R. B. Cooke. (top right) M37 Aurigae, 15-min. on Eastman Commercial, developed in DK-60A. By Dr. S. R. B. Cooke. (center) HVI 30 Cassiopeae: 2-hrs. on Super Fulgur plate. 20-in. aperture Newtonian f/6. By E. C. Silva. (lower left) M22 in Saggitarius. 70-min. on 103aO. By E. C. Silva. (lower right) M13 in Hercules. 12½-in. aperture f/8 reflector, 1½-hrs. on 103aO plate. By Clarence P. Custer, M.D.

f/5.6 wide angle survey lens and possibly some others of similar design (test first) should be equally satisfactory.

To illustrate similar sky areas taken with varied focal length lenses the Pleiades are shown on page 78 as taken with increasing focal length lenses—a 5 inch (contact 1:1), a 7 inch (enlarged about 4x), and an 18½ inch.

The advantage of Eastman's special emulsions for dim light work (see Chapter 1) should be taken in star work for exposures longer than 5 minutes, if possible to do so.

D-19 is a good star plate developer. The British also provide useful emulsions. Ask the Ilford, Inc. office at 70 West Century Rd., Paramus, N.J. 07652 for information on their emulsions HP3, Astra 111, and Zenith astronomical plates or films plus general information. Otherwise, medium speed films are usually more satisfactory with their better contrast and sharpness. I even like Contrast Process Pan film for long exposures with high aperture lenses. Using E.K. 103aO plates without filter and 103aE plates plus Wratten red filters numbers 23A or 25 permits interesting separation of blue and red stars as was shown in Fig. 10, page 11. 103aD emulsion plus filter cutting below 550 milli-microns, as Wratten 22 or 23A, provides photovisual magnitudes.

THE MILKY WAY

In photographing the Milky Way we are recording stars, star clusters, nebulae, and sometimes even comets, meteors, planets and satellites—all at once. In general a medium speed lens ($f/4.5$) or a fast lens stopped to $f/4$ covering about a 25 degree square area—or using this area of the negative—is to be recommended. True wide angle lenses are often rather slow or have to be stopped down so far that prolonged exposure is required.

Perhaps one area of our Milky Way can be used for a few illustrations. Fig. 84 is such a 25 degree (top to bottom) view of our southern Milky Way taken at $f/4$ with the 7 inch focus $f/2.5$ Eastman Ektar lens listed as a good beginner's lens and described in Chapter 2. In the center of the field about ¼th inch apart are two small nebular areas, the Trifid (M20) above, and the Lagoon (M8) below, with the large bright star clouds of Sagittarius in the lower central area. As we increase the focal length of our lens to 20 inches we see more detail of these snowy Sagittarius star clouds as shown in the excellent photo by Alan McClure—Fig. 85. The Trifid and Lagoon also appear at the top. Figure 86 is a highly enlarged small section of one of my 10 inch focus $f/2$ Schmidt camera negatives—detail is beginning to appear in these two nebulae. Such detail also present in McClure's negative was lost in overprinting required to stress the snow white star clouds. See Figs. 87, 88 for still greater detail.

Medium angle (10 degrees or so) photography of Milky

Way objects is illustrated by the North American nebula of Fig. 108A, page 95 and in Fig. 89.

STAR CLUSTERS

Standard photographic cameras can explore the so-called open clusters with the same ease as the Pleiades were covered at the start of the chapter. Other open clusters are the Beehive or Praesepe (M44) cluster. The double cluster of Perseus as shown in Fig. 92 is dimly visible to the eye and a most beautiful sight even in a small telescope. This twelve times enlargement from a 10 inch focal length Schmidt camera photo is reproduced to scale. Each cluster is about ¾ degree in diameter. Such enlargement with high resolution is permitted by use of a fine grain contrasty film as Process Pan and a high definition lens.

We'll now turn to the globular and close clusters. Here is where the narrow angle, long focus ordinary reflecting and refracting astronomical telescopes of the amateurs can be readily coupled to a reflex camera or to small plate holders. Of the work I've seen, that of Dr. Cooke, Dr. Custer, and Lt. Comdr. E. C. Silva have been outstanding. Accordingly a series of their photographs is presented in Fig. 91 with available data to guide others. Illustrated are globular and galactic clusters. The great globular cluster in Hercules, M13, (lower right) is visible to the unaided eye, an interesting test for a beginner. Messier 22 in Sagittarius (lower left) is situated in the great star cloud of the Milky Way not far from the center of our galaxy (see McClure's photo page 79). Also illustrated are three differing "open clusters". Particularly note the tremendous loose mass of faint stars in the central photograph. These lie directly between Rho and Sigma Cassiopeia.

Since exposures will be moderately long, the special emulsions made by Eastman and Ilford as mentioned previously should be considered. Otherwise medium speed films are to be recommended developed in a good contrasty developer as D-19. With long focus refractors use a yellow filter (K2) with panchromatic film or a red filter with 103aE emulsion. Fortunately reflectors are achromatic and full advantage of both their great light grasp and perfect central definition can be taken in photographing globular clusters and tightly

crowded star fields. Here is a place where precision guiding is a must, since it is often advantageous to increase even the long focus of the telescope by projection with a Barlow lens or other means. In such large long focus telescopes it is impractical to attach an even longer focus guide scope. Hence an arrangement is usually made to focus through a small secondary telescope onto a star image near the edge of the plateholder. For color use High Speed Ektachrome. If available, use a "cold camera," which effectively increases film speed—color 3 to 5X faster than normal and black and white 10X faster than normal.

Fig. 93. The Orion region. 15-min. on 103aE with 10-in. F.L. f/2 Schmidt camera. Photo (and camera) by the author.

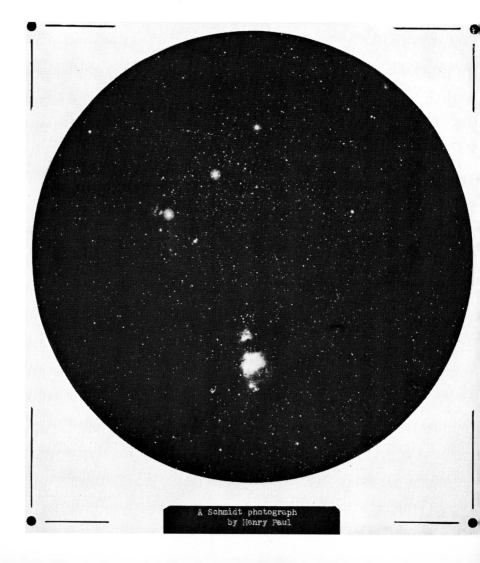

A Schmidt photograph
by Henry Paul

10

NEBULAR OBJECTS

Following the recording in 1880 of the first nebular image, photography has added more to our knowledge of dim nebulous objects of outer space than in any other area. Photographic emulsions have the valuable property of steadily adding up the effect of faint light to produce an image of objects invisible to the eye. Using large aperture to focal length ratio lenses and fast emulsions one can record undreamed of changing patterns in a comet's streaming tail as it swings near us in its path around the sun. We also have a most effective wedge to pry open the door to strangely shaped gas clouds that glow faintly far out in space, or distant dim galaxies.

The word nebula is more correctly assigned to true diffuse gaseous nebula as the glowing areas in Orion shown in Fig. 93 or the ring of Lyra nebula. However, many of the diffuse objects in the sky barely visible to the naked eye since the time of man, for example the great Andromeda nebula, have long been called nebulae and only known to be galaxies of stars with the advent of astrophotography. Subsequently, many more of such objects were shown to consist of swarms of billions of stars when spectographs came into use or when our telescopes became large enough to resolve or separate individual stars from the spiraling clouds. Endless distant galaxies are still beyond our largest telescope's resolving power and hence look like nebulae. It is therefore difficult

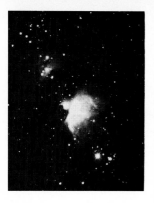

Fig. 94. By Dr. S. R. B. Cooke.

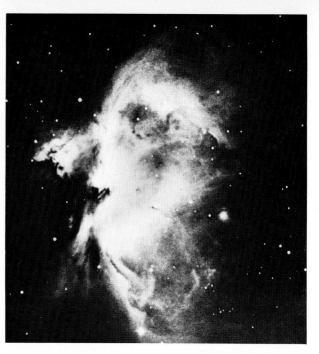

Fig. 95. By Clarence P. Custer, M.D.

at times to differentiate one from the other photographically without added tools such as the spectograph.

Keeping the above in mind, common names will be used to discuss nebular objects as we look around in the sky with our contributing amateur astronomers by means of their photographs.

NEBULAE AND GALAXIES

In photographing the parade of strange objects under this label we are constantly torn between wanting lenses fast enough to record the faint nebulae in a reasonable time and ones with long enough focal length to magnify the small sized (in angle) objects to a useful degree. Obviously compromises are constantly made by both amateurs and professionals.

Rather than try to make theoretical recommendations on what lens or camera one should use, why not see what others have accomplished photographically with the various instruments finally chosen by them for photographing these particular outer space objects.

Let's choose a familiar naked eye object, the great Orion nebula (M 42), a diffuse gaseous object only about a thou-

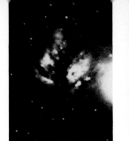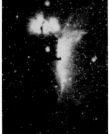

96. By E. C. Silva. Fig. 97. By E. C. Silva. Fig. 98. By E. C. Silva. Fig. 99. By A. McClure.

sand light years away in our own galaxy. It is large enough in angular size to show up well even with our smaller cameras. It is conspicuous in Fig. 93 in the sword of the constellation. This 10 degree diameter circular field (see page 86) has been reproduced near scale from a 3X enlargement of a 1.75 inch diameter negative from my 10 inch focus 5 inch aperture ($f/2$) Schmidt. This 10 degree field contains several interesting objects. In Fig. 94 Dr. S. R. B. Cooke has photographed this Orion nebula with an 18½ inch focus 6 inch aperture ($f/3.1$) Schmidt. We now begin to see more detail in the patch of glowing gas of the central nebulae. Let's take a big jump to the 101 inch focus 12½ inch aperture ($f/8$) reflector of Dr. Clarence P. Custer, who presents us with the magnificently detailed photograph in Fig. 95 of the glowing gaseous filaments and shadowy areas of this nebular giant. (See color section.)

Eugenio C. Silva of Portugal has photographed the heart of this nebula in red light with his 20 in. aperture 120 in. focal length ($f/6$) reflector at high magnification—cutting exposure for central detail only as shown in Fig. 96. This shows an entirely different character to the nebula—more like that of the drawings made years ago by astronomers using large visual reflectors. Silva has also explored even the faint nebular object (HV 30) just above the main nebula in Fig. 94 and brings this to us in beautiful detail in Fig. 97.

As our focal length has increased, lens speed has decreased with exposures being accordingly 15, 30, and 45 minutes. This illustrates sacrifices in angular area and speed required as we move out for greater magnification and detail in individual objects.

The 10 degree circular area of Fig. 93, contains two other unusual objects. Just on the immediate left side of the farthest left of the three belt stars, Zeta Orionis, is a small nebulosity—barely recorded. This strange flowing ob-

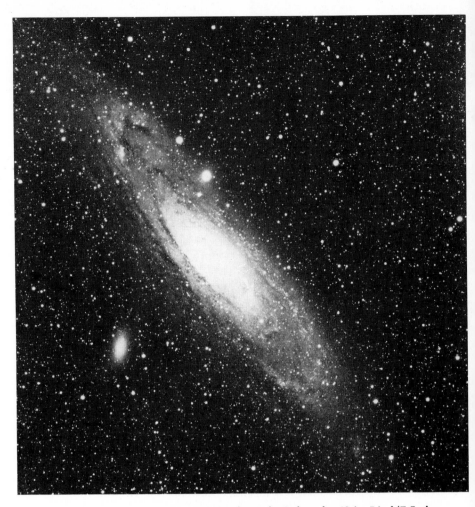

Fig. 100. Andromeda Galaxy by 49-in. F.L. f/7 Fecker
triplet. 45-min. in blue light, 11aO plate. By Alan
McClure.—Fig. 101. (left) Andromeda through short-
focus (10-in.) lens. 30-min. at f/2 on 103aE. 7X en-
largement. By the author.

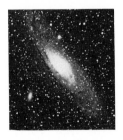

ject—Hv 28 Orionis—is brought out in full detail by Silva's 20 inch aperture reflector in a 1½ hour exposure, Fig. 98. The bright blob of the right edge is part of the over-exposed image of Zeta Orionis. About a half inch below this same star in Fig. 93 is faintly seen a dark nebula known as the horsehead nebula, shown in nice detail in Fig. 99 (Turn left border to bottom and note central object)—photographed in red light by Alan McClure with a 27.5 inch focus 5.5 inch aperture (f/5) three element lens. Here vast dust clouds are hanging as black curtains in front of glowing gaseous areas.

As a true galaxy, the titanic whirlpool of stars in Andromeda, visible to the eye, is a photographically striking object. McClure, using his 49 inch focus 7 inch aperture (f/7) lens, shows it in full splendor in Fig. 100, one of the best amateur photographs of this object I've seen. To show that much can be accomplished with smaller lenses, Fig. 101 is a 7X enlargement to scale of Andromeda taken with a 10 inch focus lens—one fifth that used in Fig. 100.

Let's explore a bit further out into space, the Schmidt being a good camera for this. In Ursa Major are two interesting saucer shaped distant galaxies near together in our field as shown in Fig. 102. The upper one, M 82, is edge on to our view and the lower, M 81, faces us. Silva and Dr. Custer with their long focus reflectors and long exposure photographs of Figs. 103 and 104 have practically moved us up to ringside seats.

Traveling out to almost the limit with amateur equipment, Dr. Custer in Fig. 105 shows us three closely grouped galaxies under the "triangle" of eastern Leo, being visible to the eye (magnitudes 9–10) in telescopes having ample field, but brought out in much greater splendor in this enlargement from a 2¼-hour exposure. At upper right, a lenticular galaxy. At lower left, we see a dark obscuring band crossing

Fig. 102. M81 and M82, distant nebulae in Ursa Major. 20-min. on 103aE. 10-in. F.L. f/2 Schmidt, 8X enlargement. By the author.

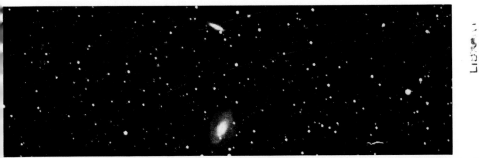

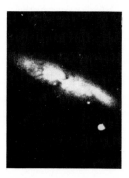

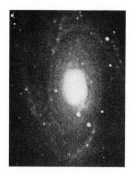

Fig. 103. By E. C. Silva.　　　　　　Fig. 104. By C. P. Custer, M.D.

the face of a galaxy. Spiral arms begin to show faintly in the nebula at the lower right. These are 10-sec. angle objects. Detail in spiral galaxies is shown in Figs. 106, 107, 108.

In Fig. 111, Dr. Custer in an outstanding photograph shows the famous ring nebula of Lyra in its true splendor —a 50X enlargement of an image of about ⅟₃₂nd inch diameter from a 2-hour exposure on fine grain Kodak III-o emulsion. A cataclysmic explosion of the central star probably started this outrushing nebular ring of glowing gas.

The aptly named rosette nebula of Monoceros stands out in the red light photograph by McClure in Fig. 112—an 80-minute exposure. See North American Nebula, page 95.

COMETS

The comets that swing silently in from outer space orbits have been considered top celestial events since recorded history. The true beauty and unusual delicate detail of the jet-like streamers from these tenuous objects have been skillfully recorded by McClure and Davis in the outstanding photographs shown on pages 98, 99. Comet Mrkos 1957d presented a streaming feathery tail as recorded in Fig. 113. Comet Arend Roland was extremely unusual in having a nose spike to spearhead its progress. Rotation of this spike is shown in Figs. 114, 115. See page 100 for Comet Ikeya.

For those fascinated with high speed lenses, comet photography offers good opportunity. Lenses of f/values of f/3 or faster are to be preferred—also the highest speed films for amateur work. Using such fast films and fast ordinary

short focus cameras the brighter large comets will produce suitable images in a minute or so without undue motion of either comet or background stars.

Naturally driven mountings as previously described are more suitable, permitting longer exposures and more fine detail in the tails. Where cometary motion is slow, a convenient star may be used for the cross hair of the guide scope for moderate length exposures. However where cometary motion is fast, as that of Comet Burnham 1959K shown in Fig. 116, we face a new problem—namely that of guiding our camera to follow it. Since comets are at best fuzzy objects, attempting to keep a cross hair centered on one, while better than nothing, may not be adequate. Tamie A. Smith in taking her photo of this comet transferred the comet's computed motion to units of correction to alternatively apply to the telescope's calibrated slow motions in declination and right ascension per unit of time (as an amateur she finds it helpful to have an astronomer husband). The faint zig-zagging of the star trails shows the alternate correction; the star trail direction indicates the comet's motion in relation to the stars; and the star trail length the comet's rapid motion in the sky in the relatively short 10-minute exposure. Figure 117 (at right) has been added to

Fig. 105. Distant trio of galaxies, brought up with 101-in. F.L. f/8 reflector. 2¼-hr. exposure to blue light on 103aO emulsion. By Clarence P. Custer, M.D.

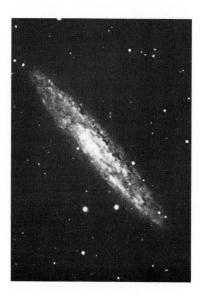

Fig. 106. Tilted spiral nebula
HV 1 Ceti. 4-hr. exposure on
Super Fulgur plate. 120-in. F.L.
f/6 reflector. By E. C. Silva.

Figs. 107, 108. Reverse spirals. Compare M101 in Ursa Major (left) 200-min.
exposure on Super Fulgur film with M33 Triangulum (right) 215-min. ex-
posure. By E. C. Silva, Portugal.

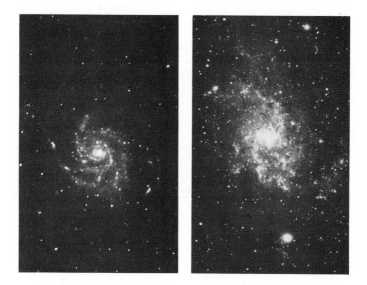

94

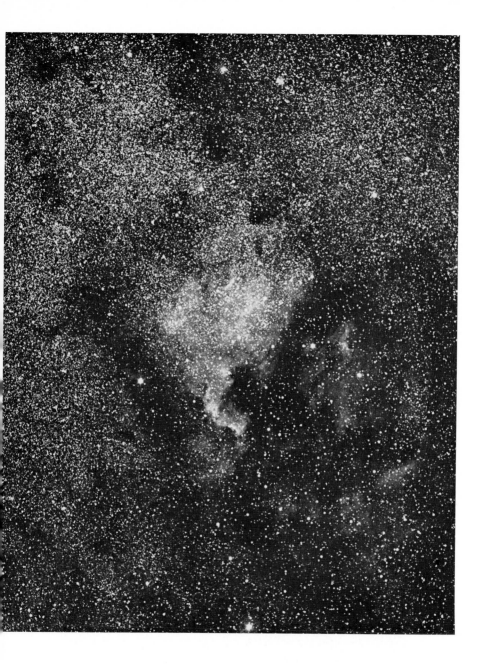

Fig. 108A. "Our Continent in the Sky," the North American Nebula. 30-minute exposure on Eastman 103aE emulsion with an f/2.0, 10-in. focus Schmidt type camera. About 8X enlargement. Photo (and camera) by the author.

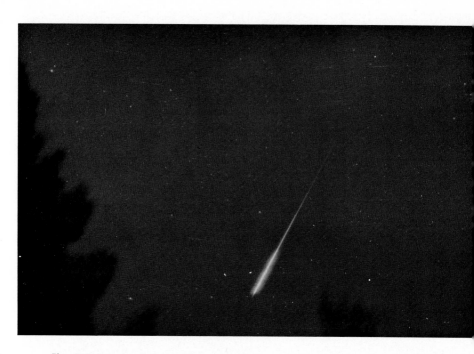

Fig. 109. Spectacular Leonid meteor flight with 10 degree trail and brilliant terminal burst. A fortunate catch at twilight during a 5-min. exposure with Tri-X film in 35mm camera. By Alan McClure.

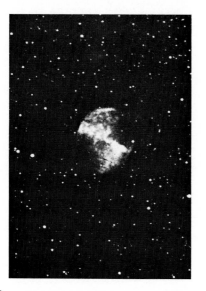

Fig. 110. The Dumbbell Nebula M2 of Vulpeculae. Long-exposure photography by E. C. Silva, Portugal.

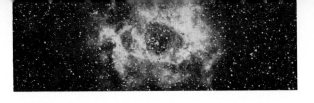

Figs. 111, 112. (left) Ring Nebula in Lyra. 2-hr. exposure on III-o spec. emulsion with 101-in. F.L. f/8 reflector. 1/32-in. image enlarged 50X. (right) Rosette Nebula in Monoceros. 80-min. on 103aE plus red Plexiglas filter. 27½-in. F.L. f/5 Zeiss triplet. Left photo by Clarence P. Custer, M.D.; right by Alan McClure.

show the effect of "enhancing" on contrast (copying original plate to a positive and back to a negative).

AURORA

We have all seen the Northern Lights of Aurora Borealis, and some of us may have viewed a spectacular colored display. Two splendid Auroral displays photographed by Dewey Bergquist are in Figs. 121 and 122. High speed lenses and films are musts. Short exposures capture detail unblurred by Auroral motion. For black-and-white films in the 200 ASA range fractional second exposures may capture the brightest displays, but 1 second to 1 minute is a more likely range to try with average films. Try the new ultra fast black-and-white films at a tenth this range. For color use Kodachrome 64 or High Speed Ektachrome.

Fig. 120 (bottom) is a common form taken with my standard f/2—35 mm. Contax. Fig. 119 (top) shows a fine overhead burst taken by Paul W. Davis with a larger f/2.5 lens. While properly used here, this type lens should be stopped to f/4 for sharp star work.

We now have a wonderful opportunity for not only full color photographs but color movies of the Aurora's pulsating action through long exposure movie photography by use of present high speed color film (ASA 160). I recently viewed a short experimental run made by Ralph Dakin with such film. He used an f/1.5 lens wide open and about a 5 second exposure on each frame in continuous sequence on an Aurora of estimated medium brightness with beautiful results. Lenses of f/.95 or f/1.0 are now available.

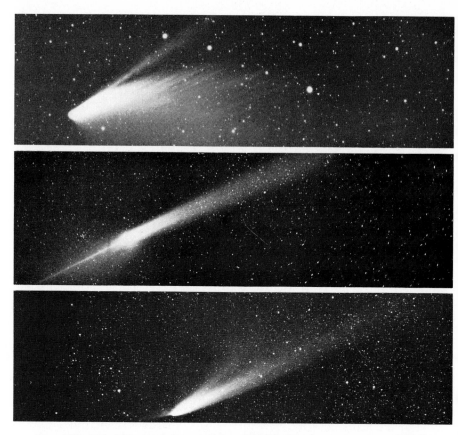

Figs. 113, 114, 115. (top) Comet Mrkos (1957d) 13-min. exposure on 103aE plate using 20-in. F.L. 4-in. aperture (f/5) Goto (Tessar) by Alan McClure. (center) Comet Arend Roland on April 24, 1957. 10-min. exposure on 103aE with 12½-in. F.L. Aero-Xenar at f/4. (bottom) Same comet, April 27-28, 6-min. exposure, same equipment. Photos by Alan McClure.

Figs. 116, 117. Comet Burnham, 1959K, 10-in. exposure on 103aO plate developed in D-19. At focus of 12-in. aperture 80-in. F.L. (f/6.7) reflector. Visual magnitude about 4.5, rapid movement of about a half degree, the Moon's diameter, per hour. (right) Same photo "enhanced" by double printing. See text. Photos by Tamie A. Smith.

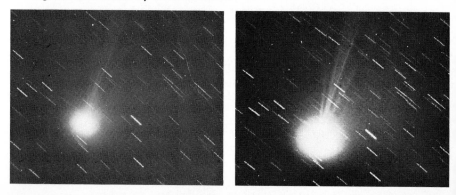

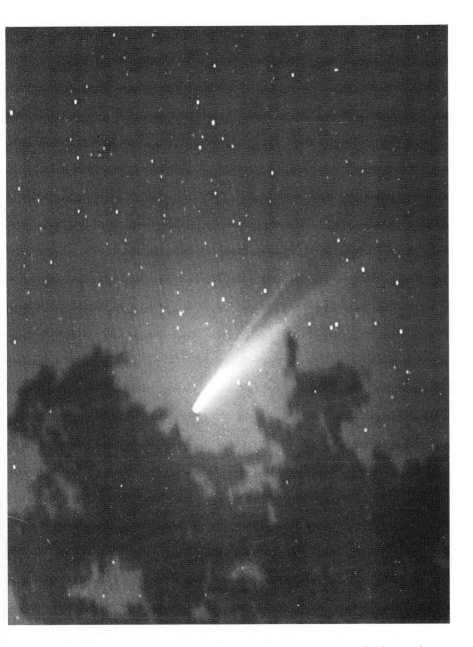

Fig. 118. Comet Mrkos, showing split fantail against a starry background. About 1-min. exposure on early Royal-X Pan, with 12-in. F.L. Aero-Ektar at f/2.5. Photo by Paul W. Davis.

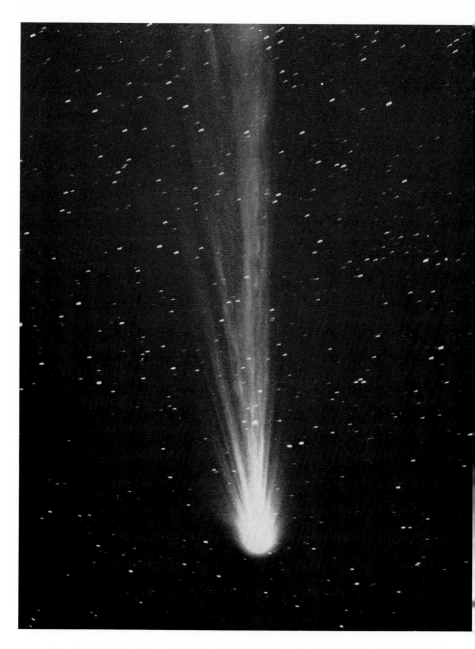

Fig. 118A. Comet Ikeya 1963a, discovered by a Japanese amateur with a $20 home-made telescope, is splendidly shown here with its striking fine detail and numerous streamers in the bright inner tail. Photographed at about 100 million miles March 14th with 49-in. F.L. f/7 Fecker lens, 103aO emulsion (blue sensitive), 35-min. exposure, 2½X enlargement. By Alan McClure.

Fig. 119. Overhead auroral burst. 15-sec. exposure on 103aE plate. 12-in. F.L. Aero Ektar at f/2.5, 4 x 5 homebuilt camera. Photo by Paul W. Davis.

Fig. 120. Typical auroral cloud with rays. About 2-min. exposure on Super-XX. Contax camera, 50mm. F.L. f/2 Sonnar. Note star motion. Photo by the author.

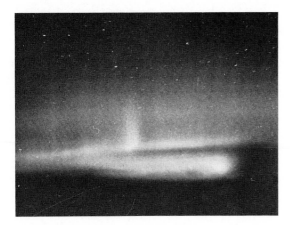

Figs. 121, 122. (top) Aurora curtain forming over Fargo, N.D. (bottom) Auroral rays. 10 second exposures on Tri-X film, Rodenstock 120 camera. Photos by Dewey Bergquist.

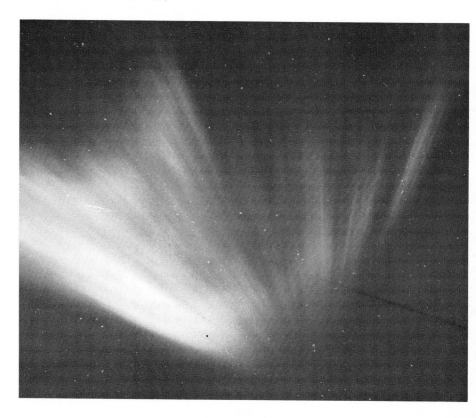

OBJECT-INSTRUMENT REFERENCE TABLE

Object	Instrument	Lens	Focal Length	f/number	Comments
STAR TRAILS	Your camera.	As available.	Any — i.e. 2"—12" but 5" to 8" good	Wide open but not faster than f/.3.	An f/4.5 lens covering 40° best all around.
SATELLITES	35 mm up to 4 x 5 cameras.	f/4.5 or faster.	2" to 8".	Wide open.	40 to 60° angle of medium coverage okay.
MOON	Camera or scope + camera	Reflector or refractor or teleph.	48" to 100", but at least 20".	f/8—f/15: by amplification to f/60	35 mm reflex camera + reflector or refractor ideal.
SUN	Camera + filter*; also + telescope.	As above. No filter at total eclipse.	As above. 3" aperture + for detail	f/15 to abt. f/60 (totality — open)	As above — amplif. lens for desired magnification.
STARS (general)	Camera. (wide angle work)	1" diameter min.— preferably larger	Any — but 5" to 12" best.	f/4 to f/8 as req. for definition.	Medium speed lens, or stop, for wide angle definition.
STARS (clusters)	Camera + scope (narrow angle)	2" dia. minimum— preferably 4" +	20" or longer	f/6 to f/15.	Long focus for greater magnification.
NEBULAE	Camera or camera + telescope.	Scopes 2" or more lenses 1" or larger	5" + for cameras. Short focus scopes	Camera f/2 to f/4.5 scopes f/5 to f/8.	Need greatest obtainable light grasp.
COMETS	Camera (+ scope if comet small)	Scopes 2" or more lenses 1" or larger	As for nebulae.	Usually wide open.	Good light grasp and angle to cover object.
AURORA	Camera.	1" dia. or larger fast lenses.	2" to 8"	Lens wide open. f/2 to f/4.5 best.	40—50° angle fast lens.
METEORS	Camera.	As available.	2" to 8"	f/3 to f/4 best.	40° angle of good coverage as by Ross f/4 W. A. Express
PLANETARY	Scope + camera.	for detail 6" + (minimum 3")	Equiv. focus of 50" to 1000".	f/15 to f/100 equivalent	6" or larger reflector + amplification lens best.

* Filter density of 4 or 5 to reduce light 10,000 to 100,000 times—no filter at totality—do not look at sun thru scope.
+ = "plus" or "or larger" as fits the case.

103

Fig. 124/125. This photo of a bolide, or bursting meteor, with the giant nebula Andromeda in the background, is likely to be the most outstanding and most published of all meteor photos—a "one in a million catch." Taken 9/12/23 by Josef Klepesta, Czechoslovakia. Presented with his kind permission.

11

METEORS

Success in meteor photography depends most on having yours lens open and camera pointing in the right direction at the right time. One is dealing then primarily in a game of chance with the odds increasingly in your favor if dates are chosen near known showers, as the Perseids of early August or Orionids of mid-October. Figure 126 illustrates such a Perseid meteor streaking down our southern Milky Way—ending in a couple of short bursts. Since there is a surprisingly vast amount of sky for our flashy visitors to enter, the more cameras we have pointing around the sky the better our chance of a "catch." Meteor photography is therefore a good area for group work. Cameras can be pooled and conversation aids in whiling away the time. A multiple camera setup such as shown in Fig. 127 illustrates an organized meteor watch in operation.

WHAT CAMERA OR LENS?

As in satellite photography we have several factors to consider, such as rate of travel, area of coverage, lens definition, etc. Since the entire problem becomes quite complex let's summarize by saying one should use a lens that will collect as much light as possible and yet retain sufficient correction to sharply cover at least a 40 degree field—conflicting requirements at best. Nevertheless specific recom-

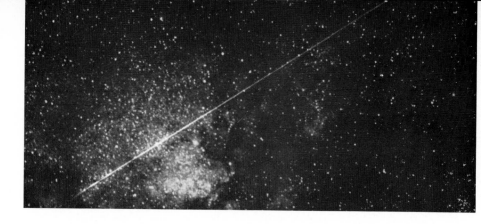

Fig. 126. Perseid meteor caught at the end of 1-hr. exposure at f/8 on 103aE plate. Bausch & Lomb Metrogon 6-in. F.L. f/6.3 lens on homebuilt 8 x 10 plate camera; driven and guided mounting. Photo by the author.

mendations can be made based on meteor photographer's experience. As a single lens type, an $f/4.5$ lens of 4 to 10 inches focal length coupled with a film or plate size to cover a little more than the above angle is recommended. Other lenses may be used by stopping down the very fast lenses to $f/2.8$; the $f/2.8$ lenses to $f/3.5$; all slower lenses —wide open.

Length of exposure is limited by stray sky light and will vary from about 10 minutes to one hour for the recommended medium speed ASA 100 to 200 panchromatic emulsions, depending on conditions of your location. As a convenience in knowing which is the beginning and end of the star trails, after a minute's exposure make a 15 second interruption by holding a card over the lens. Interruption of

Fig. 127. Photographic meteor watch team at work; John T. Hopf, left; Robert Napier, right. One such watch caught a total of 12 meteor trails on 8 negatives. See Fig. 47, page 48.

star trails by clouds and tree branches are readily recognized; however, the slow tapering off of star trails which puzzles some is caused by slow condensation of moisture or "dewing" of the lens. Two or three 1 to 3-watt radio resistors taped to the side of a lens will transmit just enough heat to the lens mount to prevent such "dewing" and yet not harm definition.

Added information may be gained on meteor flights by taking simultaneous photographs at two fixed stations 25 to 50 miles apart with cameras covering the same sky field.

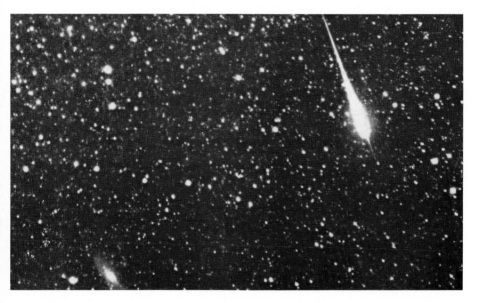

Fig. 128. Bolide bursting left of Psi Andromedae. 40-min. on Ilford HPS. 3-in. F. L. Zeiss Tessar on 2¼-in. sq. film camera mounted on 2.4-in. aperture equatorial refractor, hand driven by R.A. slow motion. Note Andromeda nebulae in lower left-hand corner. By Walter Palmstorfer, Austria.

Attaching a rotary shutter in front of the lens to break the trail ten to twenty times per second will add still further to your data. With all of the above information one can calculate height, direction, speed, etc. Prisms are added to lenses to obtain meteor spectra to furnish data on composition and color. Our newer high speed films now add a won-

107

derful opportunity for spectacular meteor photos in full color.

All equatorial mounting is an improvement, at least photogenically, in removing star trails and permitting such fine photographs as presented in Fig. 128 by Walter Palmstorfer of Austria. The size of this burst can be gauged by the Andromeda nebula in the lower left corner.

Alan McClure on Nov. 17, 1962, caught a spectacular Leonid meteor flight (see page 96) ending in a brilliant terminal burst near Iota and Theta Draconis. A visible trail lingered for about five seconds. This fortunate catch was made with twilight and moonlight limiting exposure to only five minutes.

In meteor photography the keeping of records is doubly important as regards your work being of real value to others. What records to keep is somewhat self-evident from types of data supplied throughout this book—although for brevity much data, other than of an illustrative nature, has often been omitted. No records can be too complete and quite often a key portion is missed—hence it is best to work out a record form for each area of work. For meteors one should record data relating to *equipment* as lens, camera, aperture used, film, etc.; *time factors* as date (usually covering two days, as July 31–August 1st, A.M. or P.M.), beginning and end of exposure, time of meteor flight; *positional* as area of sky (general or RA and Dec. of center), your longitude and latitude; *special* as rotary shutter speed or prism if used, etc.; *observational* as comments written *at once* on all remembered aspects of the meteor (color, bursts, trail, etc.). Meteors brighter than Venus are called fireballs and may make a rushing noise similar to an express train—often followed by one or more explosions—in the latter case these meteors are called bolides. Following passage of these larger objects glowing vapor trails may linger in the sky for some time—open up your lens and try for a spectacular photograph using a 10 second to one minute time exposure—depending on trail brightness and motion. Try time lapse with color film. This procedure may be used to capture an exploding bolide such as the one shown in Fig. 124/125.

12

PLANETARY PHOTOGRAPHY

The planets are difficult subjects for the amateur photographer because of their small angular size. Nevertheless, the photographs accompanying this chapter attest to the exacting work and skill of those who have attacked this area of outer space photography with enthusiasm and determination. Figure 129 is a parade of such excellent work on the more accessible five planets. We will devote most of our attention to planetary photographs where some surface detail or planetary shape is possible with instruments within reach of an interested amateur.

Broadly speaking, so-called ordinary photographic lenses are not very useful to us because of the stringent requirements of resolving power (definition) and focal length (for adequate image size). We should therefore primarily consider good quality refracting or reflecting telescopes of 48 inches or longer focal lengths as useful tools. This means that the average 6 inch $f/8$ reflector or 3 inch $f/15$ refractor is approaching an operational minimum for size. Larger sizes or equivalent Schmidt-Cassegrainian scopes are preferable.

In Chapter 1 we briefly reviewed the relationship of aperture to resolving power. Horace Dall of Luton, England, has spent considerable effort to dramatically illustrate the increased resolving power of larger lenses by making actual controlled laboratory tests. In making this work available, Mr. Dall states, "Presented in Fig. 131 are photographs of

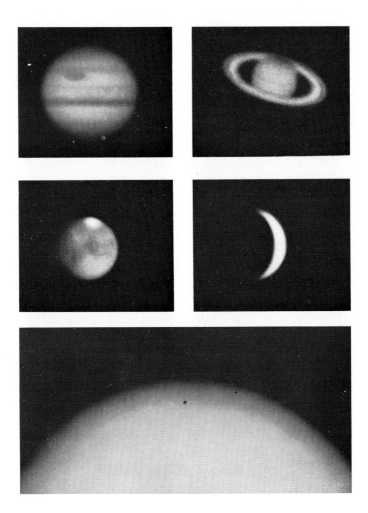

Fig. 129. Our nearby p.anets photographed by amateurs. (top left) Jupiter with red spot. (top right) Saturn. Taken with 15-in. aperture Cassegrainian telescope at 1715-in. equivalent focus. By Horace Dall, England. (center left) Mars with polar cap, through 12½-in. reflector, by Everett S. Oliver. (center right) Crescent Venus through 75-in. F.L. reflector with equivalent focus of 225-in. (Barlow) By Roland E. Rustad, Jr. (bottom) Mercury in transit along Sun's edge. 5-in. refractor 75-in. F.L. plus eyepiece projection. By Paul W. Davis.

good drawings of Saturn seen at mean opposition. Details of the crepe ring, etc., were shown in fine stippling. These six photographs are of the same drawing but taken through small apertures giving an identical view to that seen through telescopes of the stated aperture, with *perfect optics & seeing*— always using the same magnification. In addition, a small disc 1.6 secs. of arc diam. representing Ganymede (Jupiter's satellite) with 3 black belts is included at the top in each to show the best possible optical appearance in each size telescope. A double star of separation 1 second is also shown near the bottom—this is resolved in sizes 6 inches up." Fig. 130 is a superb photo of Saturn taken with a 14 inch.

Mr. Dall continues essentially as follows: With the 48 inch (aperture telescope) the large dots of the stippling are just visible. The one second double is separated by 10 blob diameters. Ganymede's appearance is nearly equal to the original. As we move from the 48 inch down to 24, 12 and 6 inch apertures image deterioration steadily takes place. With the 6 inch, Ganymede is bright but detail is lost. The one second double is still resolved and the first diffraction ring was faintly visible. With the 3 inch, Ganymede just appears. The one second double is now a slightly elongated blob. With the 1½ inch, Ganymede is missing. Diffraction has spread the light so much that it is too feeble to register on film. The one second double is a faint blob visible only on the original negative. We can now see what the old astronomical expression "empty magnification" means. (This fine example of practical demonstration pleasantly eliminates thousand of dry words of theory—author.)

While we can control the quality of our photographic equipment we cannot control a planet's angular image size. Let's take a look at this problem a little more closely. Certain planets, for example Venus and Mars, vary *greatly* in image size as they move towards or away from the earth in their periodic swings about the sun. These changes are *not* relatively small or a few per cent, as is the case with image size changes of our sun and moon. For example Venus varies in angular size from about 10 seconds to 64 seconds of angle. Mars varies from 3.5 seconds to 25 seconds in angle. This maximum angular diameter of Mars is therefore only about $\frac{1}{80}$th our moon's diameter. Let's select an arbitrary value of 20 seconds as the diameter of Mars over a

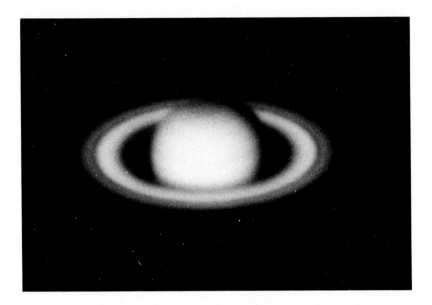

Figs. 130, 131. (above) An outstanding photo of Saturn with a Celestron 14-in., Kodak SO-410 film, 7 sec. at f/90. By Leo C. Henzl, Jr. (right) Saturn as seen or photographed through telescopes of various sizes. By Horace Dall, England.

range of favorable times, and make a few practical calculations. This angle means an image size at focus of our commonest type of telescope (6 inches f/8–48 inches fl) in the range of .005 inch ($\frac{1}{200}$th inch)—not very large!—or a hundredth of an inch per 100 inches of focal length. To find linear image diameter at the focal plane, multiply the object's angular diameter in seconds of arc by the focal length of your lens and divide by 206,265; for diameters in degrees divide by 57.3. Answer is in unit of measure used. Here is the reason for using projection or amplifying lenses to increase the *equivalent* focal length—often into the 1000 inch range, to yield a one-tenth inch image of the 20 second angular object described. One snare: if we increase focal length too much, with respect to our aperture, our resolving power will be reduced. "Guestimates" as to where to stop range from f/values of f/60 to f/100.

It is at once apparent that long focal lengths (or equivalent by projection, etc.) of larger equipment have advantages in overcoming small angular image diameter. Good lens re-

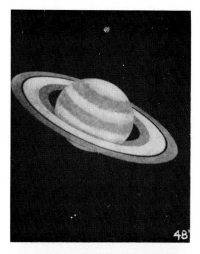

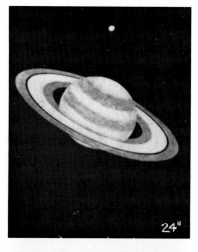

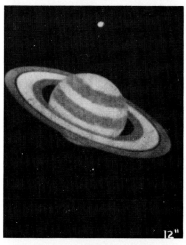

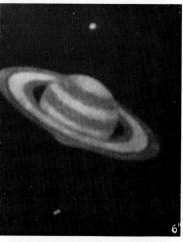

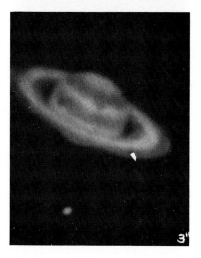

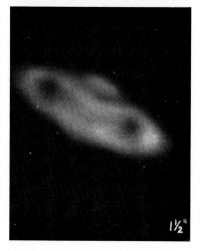

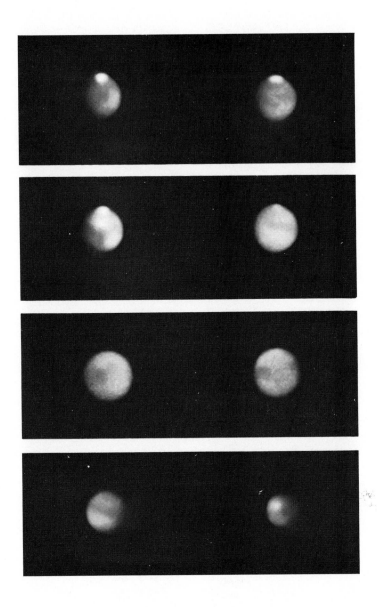

Fig. 132. A photo series of Mars as it approached and receded in its orbit. 8-in. aperture reflector with Pyrex mirror. By Dr. Alexander Dounce.

solving power, fine grain film, fine grain development, steady mounting, careful guiding (unless exposure is short enough), proper filter with visual achromats, etc., are all factors to consider; however, these can be controlled by the careful amateur. Atmospheric conditions ("seeing") is perhaps the next most frustrating other item to plague the planetary photographer. Here patience is a virtue, since there are usually some almost perfect nights everywhere. Areas of New York or of England do not rate high on a list of areas of good seeing—to say the least; and yet two of our fine contributions come from these areas. I have set up equipment for over ten "timed" celestial events all of which have been clouded out. The hot coffee and commiserating companionship of others in such instances lightened the disappointment.

Once when Mars was not in a very favorable position I was bitten by the desire to make planetary photographs. Unfortunately the desire wore off before the years passed to bring Mars nearer. At the time I tried, the calculated diameter of Mars at the focus of my 90 inch focal length and 10 inch aperture reflector was such that my film would resolve about 30 lines over the diameter of Mars—ergo the snow cap should be visible. The negative under a 20X magnifier and a strong light did show a good clumping of silver grains at the Mars polar cap; however, even a 20X enlargement was most discouraging. Whereupon I ad-

Fig. 133. Jupiter's markings. 8-in. aperture Johnsonian type mirror telescope. Instrument and photo by Horace Selby.

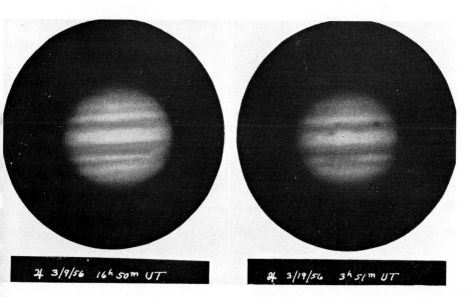

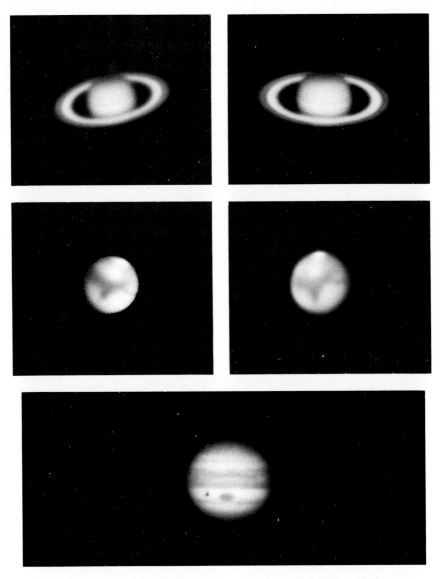

Fig. 134. Each of these photos is an example of outstanding skill in astro-photography. The planets (especially Mars) are difficult objects to capture. These illustrate, "seeing" permitting, what anyone with 6-in. to 12-in. scopes can accomplish with perseverance. Everyone must develop his own techniques. Space does not permit data other than aperture and short comment. I've seen photos only half as good with twice these apertures! Reading left to right, top to bottom—courtesy: H.F. Zeh—Saturn—8-in.—beautiful; Jim Rouse—Saturn—8-in.—superb; E. Ken Owen—Mars—10-in.—excellent; H. F. Zeh—Mars—8-in.—outstanding for aperture; Jim Rouse—Jupiter—8-in. —note satellite Ganymede's shadow—best photo with an 8-in. I've seen!

vised Dr. Alexander Dounce of upstate N. Y., that planetary photography with his smaller 7-inch reflector would probably be disappointing. On the basis that the impossible takes a little longer (particularly if Mars is moving closer), Dr. Dounce, somewhat to my pleased embarrassment, contributes the superb Mars series of Fig. 132. Incidentally, his telescope mirrors have taken prizes for optical perfection.

Most of the general principles covered in previous chapters should be considered in planetary photography; therefore further comments will be restricted to things of particular importance in planetary work. Since we are working for maximum detail, fine grain film as Kodak High Contrast Copy Film or Plus X should be considered if our aperture ratio is fast enough to permit reasonably short exposure. Since the image is usually greatly enlarged by projection prolonged exposure time using slow films may cause more loss of image definition, as a result of atmospherically caused image motion, than by the use of faster (and grainier) films allowing considerable reduction of exposure time.

To recommend specific exposure times for planetary photography is downright foolish, since these vary tremendously with a multitude of factors and can rapidly be determined while checking your instrument "set up" for sharpness of focus, steadiness, and other minute details so essential to success. Helpful tables are advertised in *Sky and Telescope.*

Fine grain developers should be used for maximum definition. I like Eastman D-76 which maintains near maximum film speed—using prolonged development (up to double) to boost the usually needed contrast. The photos of Jupiter by Horace Selby (Fig. 133) have a fine contrast balance. Note satellite and its shadow and the "red spot." With sharpness of the image again in mind, unless your lens-camera combination is very massive indeed or exposures quite long, it is cautioned that shutter recoil of many reflex cameras can raise havoc with definition—often a lens unjustly receives the blame for this. A few trial and error photographs taken by the method of a card in front of (but not touching) the lens acting as a shutter for brief time exposures can be compared with those taken using the shutter—then you will know which is better for your particular equipment. Use a ½ inch to 1 inch focus magnifier to examine the image.

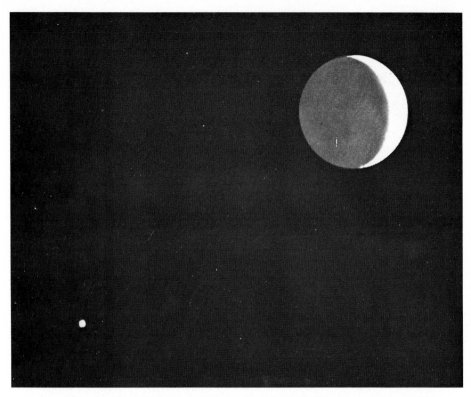

Fig. 135. Appulse of Moon and Venus, March 15, 1956. 6-in. aperture f/3.1 Schmidt; 1-sec. on Eastman Commercial film. Print masked to bring out earth-shine. By Dr. S. R. B. Cooke.

Let us turn to other contributors interested in the planets to view their work. The five part Fig. 134 is a series of black-and-white photos representing outstanding photographic skill. These superb pictures of planets were taken with apertures of between eight and ten inches.

Dr. S. R. B. Cooke shows what can be done photo-genically in Fig. 135 where Venus shines brightly while in appulse beside the new moon, illuminated by "earth shine" as it lies cradled in the old moon's arms.

Horace Dall has not only contributed unusual photos such as the stereo showing three shadows of Jupiter's moons in transit across the planet's face (Fig. 2), but has added a useful tool in his device to correct atmospheric dispersion effects. These are marked with low altitude objects—particularly when below a 20 degree horizon to object angle. We have all seen this when telescopically observing low hanging bright

objects in the sky—red on one side and blue on the other. Filters cause great light loss and prevent true recording of the object, or use of color film.

A glass refracting wedge or prism of proper angle correctly oriented and located in the light path will neutralize this error; however, it is much more practical to use Dall's system of taking a two element lens in the light path (as a Barlow, or projection lens), separate the elements with oil instead of the permanent cement, and arrange them in a cell so that one element can be moved off center vertically (with respect to the horizon) to readily nullify any degree of atmospheric dispersion needed at the time. One can view this visually if he wishes, before taking the photo. In the introductory matter, facing page 1 (Fig. 3), Saturn 12 degrees above horizon is shown at the left photographed without atmospheric dispersion corrector or neutralizer, and at the right with corrector. Note the marked improvement.

At the top of the same page (Fig. 2) Mr. Dall presents a stereo pair of Jupiter photographs taken at about 15-minute intervals showing shadows of three of its satellites—a rare event.

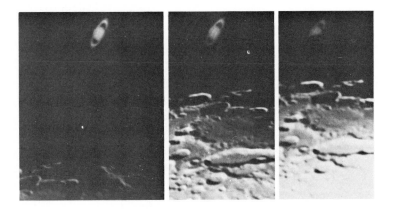

Fig. 136. Three phases in the occultation of Saturn by the moon. In the last photo Saturn is partially hidden by the moon's unilluminated invisible edge. 8-in. aperture f/8 Newtonian reflector, 8mm Brandon eyepiece projection to f/115. Exposure 1½ sec. on Royal Pan film. By D. Milon.

13

COLOR PHOTOGRAPHY

At first thought it would seem that to photograph night sky objects one would only have to load color film and "shoot." While this is true, first-try results may be disappointing. Three basic handicaps face the amateur trying for color photographs of heavenly objects. They are the dimness and color (or spectral characteristics) of the light coming from these objects, the relative slowness, compared to black-and-white, of color films, and reciprocity law failure of these films (see p. 6). To make matters more complex, such "failure" on long exposures can differ for each color or wavelength of light. Thus the color in photographs of celestial objects can stray considerably from their true color according to the film used, processing, the speed or light-gathering power of the lens or telescope used, brightness of the object (and clarity of the sky), exposure time, etc. Even film temperature can play a role!

The need for more light on the film turns the amateur 35 mm. camera user to high-speed (high aperture ratio) lenses for color photos of *extended wide angle objects* as comets, aurorae, the Milky Way, etc. Fast $f/1.2$, $f/1.4$, and in longer focal lengths, $f/2.8$ lenses are desirable. The super-speed lenses in the $f/1.0$ area have value for very dim phenomena, such as fainter aurorae, gegenschein, various halos, etc. For narrower angle, extended area, deep sky objects, such as gaseous nebulae and galaxies requiring longer focal lengths *plus* speed, amateurs often turn to reflecting telescopes faster

than the common $f/8$ instruments. Speeds of $f/4$ to $f/6$ are preferable, even though these have restricted fields of good definition, usually not more than a one-inch circle on film at the prime focus. To photograph the dimmer stars one can only turn to larger apertures for more light and, of course, longer focal lengths when more separation is desired. What several experts have to say in the following pages can serve to guide you on films, exposure times, lenses, and instruments. While exposure time most often must be finalized by trial and error, a starting point can be gained from others using similar conditions to yours. For extended areas covering the entire film, as lunar and solar surface work, a sensitive cadmium cell meter such as the Gossen *Luna-Pro* electronic, or current similar type meter, can be readily attached by a fitting to provide a close starting point. A flexible fiber-optics attachment even permits "spot" readings of smaller areas on the ground glass! Nevertheless, many objects are rather dim or small for such ordinary meters to function.

I've been fortunate in having several amateur friends who have been willing to share their experience with you. Each, among other achievements, has taken superb photographs of astronomical objects, many in full color. Each also excels in one or more areas of knowledge related to the problems facing those striving for outstanding color pictures.

HIGH SPEED LENSES IN ASTRONOMY
by Ralph Dakin

During recent years a large number of excellent quality, high-speed lenses have been made available for 35 mm. cameras. These, combined with new higher speed color and black-and-white films, have opened up a new field in astronomical photography for the amateur. This combination now makes possible some very interesting and scientifically valuable sky pictures, *without the need for clock driven or guided exposures.*

Suitable extended area objects for unguided exposures are:

Star Trails	Meteors	Comets
Constellations	Zodiacal Light	Aurorae
Satellites	Gegenschein	Stellar Spectra

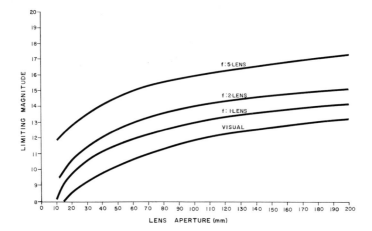

Fig. 137. Graphs showing limiting star magnitudes visible and recordable by three differing speed (f/value) lenses plotted against the effective apertures (diameters) of such lenses.

The photography of stellar images is dependent primarily on two factors: effective lens aperture and exposure time. The effective lens aperture is simply the focal length divided by the *f*/number of the lens; *e.g.,* for a 50 mm. *f*/2.0 lens the effective aperture is 50/2.0 or 25 mm. Figure 137 shows the limiting magnitude that can be recorded by a lens with a given effective aperture under black sky conditions away from city lights. Note that the limiting magnitude is substantially less with a high-speed lens. This is caused by the rapid build-up of sky fog by high-speed lenses. While the speed with which the stellar images are recorded is dependent on the effective aperture of the lens, the speed with which the luminous sky background is recorded is dependent on the *f*/number of the lens. Astronomers on the moon will not have this atmospheric problem and will be able to expose their films with extremely high-speed lenses for very long times without a background fog build-up.

STAR TRAILS—Star trail photographs can be made with almost any lens, camera, and film combination. The length of trail recorded on the film will be dependent on the focal length of the lens and the exposure time. The following shows the angular length of trail for stars with a declination of 0 degrees for different exposure times.

122

Exposure Time	Angular Motion of Image
24 hours	360 degrees
1 hour	15 degrees
1 minute	15 minutes
1 second	15 seconds

The length of the trail on the film varies in direct proportion to the focal length of the lens and can be determined by: $L = F \times E \times 0.00007$ where:

L is the length of the trail
F is the focal length of the lens
E is the exposure time in seconds

With a 50 mm. focal length lens and an exposure of 10 seconds, the trail length will be only 0.035 mm. (0.00138 inches), approaching the resolving power of fast grainy emulsions.

With high-speed lenses there is a limitation on the length of exposure because of the build-up of sky fog. Under very black sky conditions this limit, with high-speed films, is about 10 minutes with an $f/1$ lens and about 60 minutes with an $f/2$. Local city lights will reduce these limiting exposure times substantially. Thus, for long-exposure star trail photographs the lens should be stopped down to at least $f/5.6$. The effective aperture (E.A.) of the lens then becomes the limiting factor in determining how faint a stellar image will be recorded. Many more stars will show on the film when a 135 mm. $f/5.6$ lens (E.A. 24.1 mm.) is used than when a 50 mm. $f/5.6$ lens (E.A. 8.9 mm.) is used.

CONSTELLATIONS — Excellent constellation photographs can be made with the common 50–58 mm. $f/1.2$ to $f/1.4$ lenses available on most 35 mm. cameras. An exposure time of only 20 seconds will record more stars than are visible to the naked eye on either black-and-white or color films, with ASA speeds of 100 or more. This 20-second exposure will result in star trails about 0.07 mm. (0.0028 inches) long with a 50 mm. lens, and these photos show essentially no trailing when projected for an audience.

This length of trail is for stars near the ecliptic (0 degrees in declination). At the pole there will be no trail and in between the length of trail can be computed by multiplying the 0 degree trail length by the cosine of the declination angle (see Fig. 138).

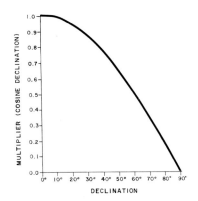

Fig. 138. Star trail lengths. Multiply length calculated for 0° declination by cosine of declination used. Read from curve.

Most of the constellations can be recorded completely with a 50 mm. focal length lens, and a collection of such color slides becomes a very effective tool for showing the sky to a group. Some of the constellations cover too large an area in the sky and require the use of 35 mm. and 28 mm. lenses with exposure times increased accordingly since their EA's are smaller.

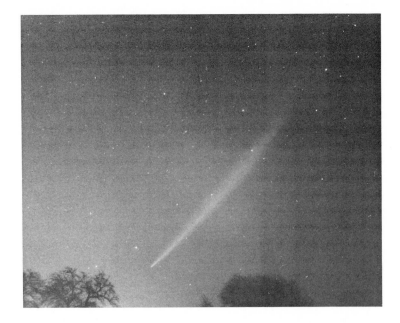

Fig. 139. Comet Ikeya-Seki. 10-sec. exposure with a 50mm f/0.95 Canon lens on Plus-X film, fixed camera. Note sharp star images. By Ralph Dakin.

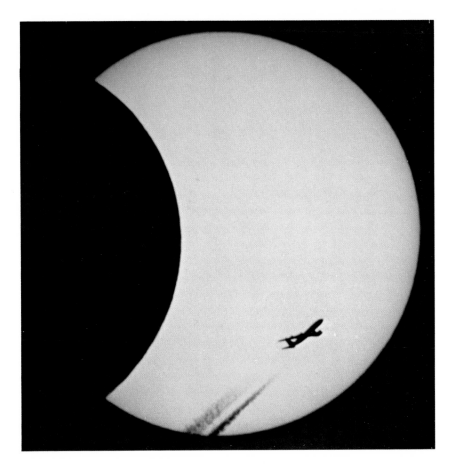

Jet plane crossing a partially eclipsed sun—a rare "catch." Photo by Mike Sankey and Wayne McGill, taken with an 8-in. Celestron. Courtesy Celestron, Inc.

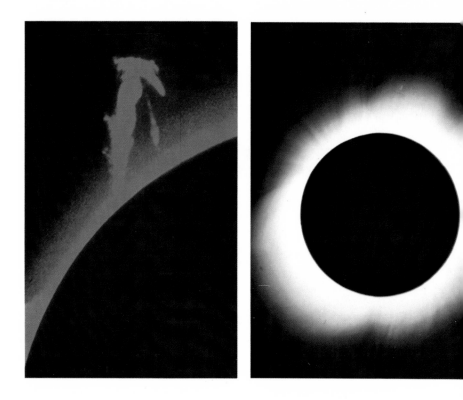

(Clockwise) A spectroheliogram made in hydrogen's red light shows great surface and prominent detail. The enlarged section shows a single tongue of flame bursting out to 100,000 miles or more. Such would encompass many earths. Note material falling back to surface. Photo by Walter Semerau who, though he calls himself an amateur, is known the world over for outstanding photographic and special instrument accomplishments.

A solar eclipse was a fearful and awe-inspiring event to earliest recorded man. Today it is still a major scientific event. Totality with its full coronal beauty, as recorded with a 3½-in. Questar. By Boysinger and Peterson (from Denver Museum of Natural History Expd.) at Lake Rudolph, Kenya. Courtesy Questar Corp.

A rare photo faithfully showing the famous "diamond ring" effect occurring as the last rays leave or the first rays emerge from behind the moon. Fractions of a second are important in such a superb photo. By Mark Bowers.

A rare solar event, an annular eclipse—the moon is nearer to the sun, and since close to the horizon, air refraction causes the flattening or oblateness. Courtesy Ralph Dakin.

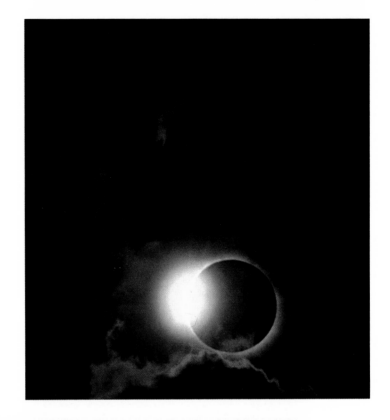

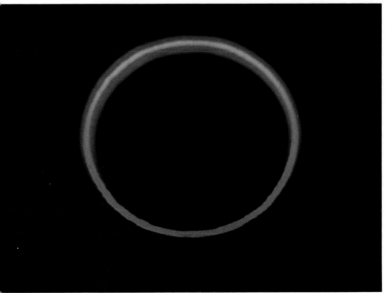

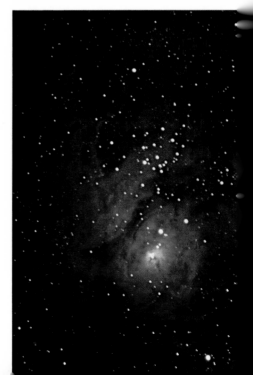

(Above) Aurorae, particularly as one ventures north, are portraits in themselves. The shimmering, raying, and flashing of an active aurora on a dark night in any or all colors of the rainbow are a gorgeous sight. They actually make a rustling noise on a truly quiet night. In this picture a bright blue swirling aurora hangs over St. Paul, Minn. Photo by S. Schultz, Jr. (Right) The Lagoon nebula as taken by James Matteson with a 14-in. Celestron—cold camera. Courtesy Celestron.

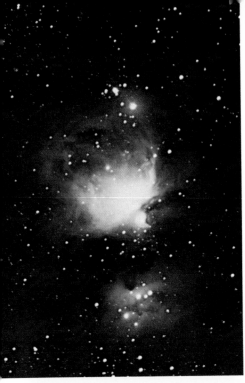

(Left) The Orion nebula taken by James Matteson with a 14-in. Celestron—cold camera. Courtesy Celestron. (Below) S. Schultz, Jr. has not only captured a colorful aurora in this picture, but also the rising moon and reflections of both in a lake.

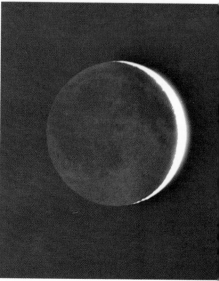

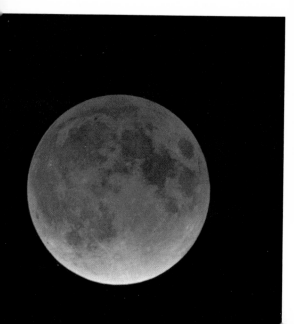

(Counterclockwise) Triad of the crescent moon, Venus (bottom), and Saturn in the evening sky—quite a beautiful sight. During exposure a plane streaked across the sky. By B. Lundegard.

Our moon often presents us with colorful displays. A total eclipse not quite in the center of earth's shadow creates a colorful range of reds, unusually so in this eclipse. Note the dark areas that look like a rabbit. By S. Schultz, Jr.

Often termed "The old moon cradled in the new moon's arms," or vice versa. Shown here at its best, the moon two days old. By J. K. Rouse.

Jupiter's red spot and shadow of the moon Io, which is nearly as big as our moon, as photographed from Pioneer 10. Jupiter is the largest of our planets; the red spot could swallow several earths.

Conspicuous by their absence are photos of the other planets.
Color photos of the beautiful planets Saturn, Jupiter, and Mars as yielded by instruments of a size most amateurs can afford are very small. Special developing and printing techniques are essential to do these justice. Success can be had, but only by the careful and skilled work of an experienced and enthusiastic amateur who is not misled by photos from giant observatories and space probes.

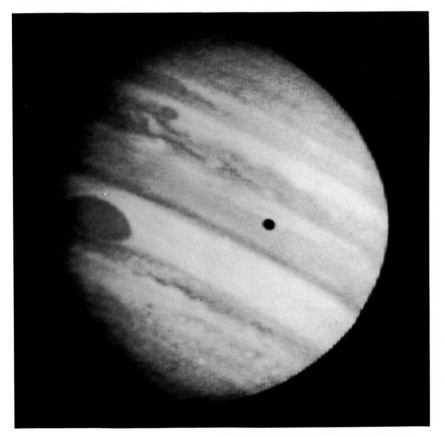

(Above) The sparkling Pleiades, or "Seven Sisters," are presented with the pale blue filamentous nebulosity against a blue and yellow star background. One star is not in this frame, and one has faded over the years. By Evered Kreimer with an 8-in.—cold camera. (Left) Here bluish Comet Bennett shines splendidly against a black backdrop richly studded with stars. As expertly photographed by Dennis and Judy Cassia.

SATELLITES — Man-made satellites against a background of star trails make very interesting photo subjects. Your high-speed lens will permit photography of very faint as well as bright subjects. By planning ahead with the aid of satellite finding charts it is possible to obtain trails of two or more on one film!

METEORS — As meteors streak across the sky they create a bright trail that is difficult to get with slow lenses. Here, as with stars and star trails, the effective aperture of the lens is more important in recording faint point objects than the f/number, but the high-speed lens has a larger effective aperture than a slow lens of the same focal length.

ZODIACAL LIGHT AND GEGENSCHEIN — The zodiacal light appears as a very diffuse patch of luminosity, conical in shape, rising more or less obliquely into the sky above the horizon at twilight. Its visibility varies considerably throughout the year and with the observer's geographical position. Since its greatest extension is along the ecliptic, it is more easily seen at lower latitudes and is best for observers on the equator. For northern and southern observers it is best seen near the spring and fall equinoxes. On nights when the atmosphere is unusually clear the glow can be seen to continue as a very faint band as far as the antisolar point, where it brightens slightly into a patch of light known as the Gegenschein or counterglow.

Most of the photos taken so far have been made with very high-speed (f/1 or faster) simple lenses. There is no reason why the modern high quality high-speed lenses cannot show both clearly. High-contrast films are needed to show either the zodiacal light or the Gegenschein, although I have a photograph of the comet Ikeya-Seki showing the zodiacal light in the morning sky.

COMETS — Large bright comets are excellent subjects for ordinary high-speed lenses without the need for expensive and time-consuming long guided exposures. The photo (Fig. 139) shows comet Ikeya-Seki taken with a 50 mm. f/0.95 lens with a ten-second exposure on Plus-X film. One taken with a 75 mm. f/1.5 lens clearly shows the zodiacal light as well as the comet with only a 20-second exposure on High Speed Ektachrome film.

AURORAE — Aurorae are another excellent subject for the high-speed lens in both black-and-white and color. Depending on the brightness of the particular display, the exposure may vary greatly. An excellent method of testing is to use a Polaroid, permitting time exposures with 3000 film. Then ratio the ASA speed to your color film speed and expose accordingly.

STELLAR SPECTRA — Stellar spectra is another field that has been entirely investigated by the professional until now. One reason has been the difficulty of obtaining high-quality diffraction gratings. Of course, prisms can also be used, but to obtain enough dispersion with a prism requires one with a very large angle and high refractive index. High index glasses are usually very yellow and little of the blue end of the spectrum gets through to the film. Diffraction gratings are now available in a very large range of sizes and types from Bausch & Lomb in either transmission or reflection type. They are fairly expensive but well worth the investment.

By simply mounting the grating in front of the camera lens and orienting the grating so that the dispersion is at right angles to the diurnal motion of the stars, one can obtain the spectra of a number of bright stars on each exposure. Mount the camera on a sturdy fixed mount and *not* on a clock-driven mount. Since the grating has been positioned at right angles to the diurnal motion, the height of the spectrum lines will be equal to length of the trail.

LENSES

Most name-brand lenses supplied with 35 mm. cameras today are surprisingly good for photographing the sky. A very simple test for a lens is to load the camera with high-speed black-and-white film, aim it at the sky on a moonless night, and open the shutter for about 15 seconds. After processing, examine the negative with a high-power magnifier or a microscope. A perfect lens would show point images everywhere in the field. *No* lens will be perfect with this test, and all will show some areas with mild flare or comatic images. Run the same test on an $f/2$ lens of 1940

vintage and you will appreciate the advances that have been made in lens design in recent years. If you stick to the well-known brands such as Canon, Miranda, Nikon, Leica, Pentax, and Zeiss there will be no problem. Of course, it is best if you can arrange to test the lens before purchase. Some of the very inexpensive lenses, such as those sold by Spiratone, do an amazingly good job. Below is a list of useful focal lengths:

50 to 58 mm. standard $f/1.2$ to $f/1.4$ — Excellent for general use.

90 mm. $f/2.0$ Summicron — Unsurpassed.

85 to 135 mm. $f/1.5$ to $f/2.0$ — Many available and useful for narrower fields. My Spiratone unit is excellent.

35 mm. W. A. $f/2.0$ to $f/2.8$ — Excellent for aurorae and where moderate wide-angle is needed.

24 to 28 mm. W. A. $f/2.5$ — Several good ones available and useful where extra wide field is needed.

50 mm. $f/0.95$ Canon ultraspeed — Excellent quality for such a high-speed lens. Will fit only Model 7 camera but can be easily adapted to a simple camera body for special use as an astronomical lens.

180 degree super-wide angle lenses — Two are: 8 mm. $f/2.8$ Fisheye Nikkor for Nikkormat camera and 9.8 mm. $f/1.8$ Kinoptik for Alpa Reflex camera.

180 degree Spiratone super-wide attachment — This interesting attachment is designed to fit a variety of standard lenses. Its speed is limited to $f/5.6$ with a 50 mm. and $f/8$ with an 80 mm. lens.

Many older lenses not listed in this brief summary will do an excellent job for the amateur and professional astronomer (see also page 23). Lenses constantly improve and a new lens, just the one we've been looking for, may become available! Consider Vivitar's newest "Zooms."

My experience with color films has been limited to Kodak and Ansco products. For all-around use I prefer High Speed Ektachrome, daylight type. It provides high speed with fine grain and very faithful color rendition. Anscochrome 500 will bring in more stars in a given exposure, but the background density is quite a bit lower than High Speed Ekta-

chrome. Kodachrome-64 is an excellent film for recording some astronomical subjects because of its higher contrast and its lower Reciprocity Law failure. For exposures exceeding about 100 seconds, it is actually faster than High Speed Ektachrome. Its higher contrast should make it ideal for faint objects such as comets. Also consider Kodacolor II.

A few supplementary comments to Mr. Dakin's experiences above, based on my own observations, follow. An exposure of only 15 seconds on comet Ikeya-Seki through an 85 mm. $f/1.4$ Komura lens wide open on High Speed Ektachrome produced a beautiful projection slide, although a trace underexposed. A black-and-white reproduction is similar to Mr. Dakin's photo (Fig. 139). Don't hesitate to take a few longer exposures, even if star trailing results. Striking pictures may still be had, as may be seen in the fine photo by Dr. Sherman W. Schultz, Jr. (Fig. 140). Here the full sweep of this comet over a large angle of the sky is dramatically brought out by the power line tower in the foreground. Don't overlook possible striking color photos of solar and lunar "halos" and related phenomena.

Fig. 140. Comet Ikeya-Seki (11/4/65) *about* 1-min. exposure with a 55mm f/1.8 Takumar lens at f/2 on Tri-X film, fixed camera. Note star trailing and vast angular sweep of this comet. By Sherman W. Schultz, Jr.

Selecting a lens can pose several problems. To support Mr. Dakin's statements, buy the best lens (usually the highest priced) you can afford. I'm partial to Leica lenses, and a 90 mm. $f/2.0$ Summicron surpasses in edge-of-field definition anything I've ever tested — nice sharp round star images. Carl Zeiss lenses are also excellent, and used ones, particularly of more recent manufacture, make good buys at about half the price of new lenses. Although a bit slow, the superb $f/5.6$ Schneider Symmar in 150 mm. and longer focal lengths should make an excellent lens for star photography for cameras from 35 mm. to 4″ x 5″ size, since it may be used wide open, whereas many faster, more expensive lenses have to be stopped down anyway for similar definition. A lot of lens for the money can be had in the better quality newly designed Japanese optics, as made by Nikon, Canon and makers of similarly priced equipment. If you must economize drastically, I too recommend the Spiratone lenses Mr. Dakin mentions. If not satisfactory to your test, take the small (10%) return charge loss, test another, or move to some other brand. Dramatic astro photos have been taken with lenses far from perfect! No lens should be accepted that does not have reasonably good central definition when wide open (where much astro work is done). It's the definition at, or near, the outer edges of the frame sides that should be checked to see if it is satisfactory for star work. There will always be considerable "fall off" here when wide open, but this should not be such as to appear horrible, like "flying white seagulls," on an 8 x 10 enlargement. When the lens is closed down two stops, the edge definition should approach that at the center. *Broadly speaking,* to cover a 35 mm. frame with reasonably sharp overall star definition at full aperture, it's well to choose a lens of 75 mm. or longer focal length, *i.e., about* 30° angular coverage rather than the 50° or so of normally used lenses. Expect considerable "fall off" at the corners in most shorter focal lengths of even modest aperture — a loss that must be accepted, or speed greatly sacrificed, for wide angle star photos.

I test lenses from wide-angles to about 135 mm. of $f/1.0$ to $f/2.8$ apertures in a manner similar to that Mr. Dakin recommends. With a black-and-white film of ASA 1000 or better (such as Royal-X Pan), the tripod-supported camera

is pointed at the North Star for a 10-second exposure of the polar area on a clear dark night with the lens wide open and set at infinity. A flexible cable release is used to open and close the shutter with bulb (B). However, an opaque card is hand held just in front of, but not touching, the lens to act as a *non-jarring* shutter for the 10-second exposure — this is important. Develop fully. Examining the star images over the entire field with a 10 to 20X magnifier proves quite educational. If one uses the same exposure and keeps a file, this allows valuable direct comparison of lenses for aberrations.

Mr. Paul W. Davis' superb astronomical photographs appear throughout this book. He writes as follows concerning his present equipment:

"The cameras used in star photography number four. First, a twelve-inch Eastman Aero-Ektar $f/2.5$ gives excellent coverage on a 4 x 5 plate. This lens has been used with good results on star fields, comets, and aurorae. It requires very careful focusing and I have made minute changes in the rear element separation. Bad features: too heavy and not easy to mount (see Fig. 21, p. 22).

"The one I like best (easy to use) is a 35 mm. camera with 75 mm. E.F.L. $f/1.5$ Zeiss Biotar. It is just right for star fields in the Milky Way using six to eight minutes exposure with High Speed Ektachrome. It shows nebulae and dark rifts in Sagittarius regions, and is also good for coverage of star fields around M31, the Pleiades and groups in Cygnus. It was used successfully to record comet Ikeya-Seki.

"For constellations a 40 mm. $f/2.8$ gives excellent results with a two-minute exposure. Longer exposure shows too many stars, confusing the viewer.

"For eclipse photos and pictorial views of sun and moon near the horizon, a 640 mm. $f/9$ Novoflex gives fine results. It is a beautiful lens and also fine for bird photography. For detailed photos of sun, moon, and star clusters a 35 mm. camera is attached directly to a Cave 12½″ reflector."

Most regrettably, not all photos can be presented here in full color. The examples of color astrophotos presented in this book are only a few of the many fine photographs that have been published. The journal *Sky and Telescope* has good color reproductions on some of its covers. Aurora, March 1967; Leonid Meteor Shower, Jan. 1967;

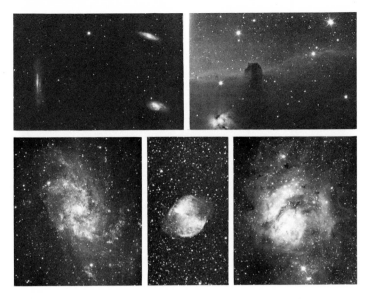

Fig. 141. These and other deep sky objects present challenges for high resolution work in color. As presented a trio of galaxies in Leo; the dark Horsehead nebula; spiral galaxy M 33; the Dumbbell nebula; and the Lagoon nebula, with an f/7 12½-in. aperture reflector. By E. Kreimer.

Lunar Eclipse, Feb. 1965 (painting); Solar Eclipse, Oct. 1965 (water color); Lunar Eclipse, March 1964 cover. Color slides may be obtained from Tersch Enterprises, Astronomy Charted, etc. Emphasize you wish "top quality" copies only for your work, since such copies can be excellent if made with care. Extra large color (and black-and-white) prints from Astro-Murals. Write California Institute of Technology for their "Catalog of Photographs and Slides from the Mount Wilson and Palomar Observatories."

COLOR IN ASTROPHOTOGRAPHY
by George T. Keene

In recent years, more and more amateur astronomers have turned to color photography. Sometimes the results have been quite successful, but often the color rendition has been disappointing. Photographs of the planets by amateurs usually show realistic tones, but the color of an aurora or a bright nebula often differs from that recalled by the photographer. Why is color film sometimes successful and other times not?

While three film color separation methods can be used, a

more direct method is to use modern color films, such as Kodachrome, Ektachrome, and Anscochrome, which employ three thin layers each sensitized to a different band of the spectrum. The speed of each layer is such that with normal exposure, the film will produce a neutral scale of grays from neutral objects. Reproduction of colors is then fairly satisfactory for most subjects found in nature, but the film may easily give wrong answers for objects that radiate a line spectrum or have reflectance curves that change rapidly with wavelength. There may also be problems if the exposure time is substantially longer than for a normal snapshot, which is often the case in astronomical photography.

Many factors can modify the proportionality between the amount of light received and the color formed in the film. Most important are chemical interactions between the light-sensitive film layers during processing and the effects of different exposure times on speed and contrast.

This last complication, the failure of the reciprocal relationship between light intensity and necessary exposure time — referred to as reciprocity failure — is of great concern to astronomers. With an ordinary black-and-white film, for example, we might expect that two stars differing by 10 magnitudes or 10,000 times in brightness would give similar images if the fainter were exposed 10,000 times as long as the brighter. But in general the two images will not be similar, because both the contrast and the sensitivity of the film will be different with the longer exposure; in fact the film will be much "slower" for long exposure times. The loss of speed for exposures of several hours duration is so great that astronomers often must use emulsions specially made to minimize this drawback. Thus, films and plates of the Kodak Spectroscopic antihalation 103a type are a common choice for photographs requiring long exposures.

For color film, reciprocity failure may affect in different ways the responses of the individual light-sensitive layers, as indicated graphically in Fig. 142 (left). The resulting picture is distorted in color balance and contrast. Sometimes these shifts can be partially corrected by color filters used during long exposures, and reciprocity effects are reduced if the film is exposed at low temperatures.

The combination of reciprocity failure and sensitivity effects would seem to make color films a rather poor tool for astrophotography. In a one-hour exposure, however, we can restore the color balance of High Speed Ektachrome film by using a CC20 red filter. Then the colors of faint objects that radiate a continuous spectrum will be correctly rendered. The planets, shining brightly by reflected sunlight, also have a continuous spectrum, but are photographed without a filter since short exposure times are used. But the faint nebulae, nearly colorless to the eye, appear red in photographs. Even with the correcting filter, the Orion nebula photographs bright red, although visually it appears slightly bluish-green. This difference can be understood from the right diagram of Fig. 142 in which the nebula's radiation is represented by the four vertical lines. These are two hydrogen lines at 6563 and 4861 angstroms, and a pair of oxygen lines at 4959 and 5007 angstroms.

The spectral response curve of the eye at low levels is indicated by the dashed curve. The dark-adapted eye sees the blue-green lines with nearly its peak sensitivity, but is virtually blind to the red hydrogen line.

The three humped curves labeled B, G, and R are the relative sensitivities of the three emulsion layers in High Speed Ektachrome. The green lines of the nebula to which the eye responds fall in the dip between the peaks of the blue- and green-sensitive emulsions. On the other hand, the red hydrogen line lies very near the peak of the response curve for the red-sensitive layer in the film; hence it predominates in the color photograph.

Fig. 142. (left) With High Speed Ektachrome (color reversal film), reciprocity failure affects the red-sensitive emulsion differently from the others, changing color balance and contrast. (right) Spectral response of the eye (dashed curve) and R, G, and B layers of H.S. Ektachrome. Vertical lines show emission from gases in the Orion nebula.

What then is the true color of the Orion nebula? If we were close enough to see its colors without a telescope, it would appear as a peculiar pearly pink — a curious blend of the red and blue-green wavelengths that our eyes and color films record with such very different results.

While nebular photography requires a telescope, the aurora offers colorful displays over a wide field of view and may be recorded by amateurs with ordinary cameras. With modern color films, use exposures running 10 to 60 seconds at $f/2$ or $f/2.8$, depending on the motion and brightness of the display. Exposures can be further increased for arcs and bands and other stationary forms. Be sure the camera is motionless during the entire exposure.

The aurora is caused in our outer atmosphere by the fluorescence of nitrogen and oxygen that have been energized by particles from the sun. As with nebulae, auroral radiation is confined to certain lines and bands in the spectrum, so that it is difficult to catch on film hues that match those seen by the observer directly. Nevertheless, color pictures of the northern lights generally give pleasing results.

Because they are brighter and have continuous spectra, the planets offer more satisfactory results in color to the amateur who has the proper telescope and camera equipment. Images of Mars, Jupiter, and Saturn are discouragingly small in amateur telescopes, even with effective focal lengths of 600 to 700 inches. Image brightness at $f/50$ or $f/70$ is low, so a fast (and more grainy) film must be used.

With a daylight speed index of 160, High Speed Ektachrome allows Mars' colors to be recorded in half a second at $f/50$. Exposures for Jupiter run about one second and show considerable color detail in the various belts and zones, and in some years the giant Red Spot is prominent. If you observe where the air is very steady, Kodachrome-25 or Kodachrome-64 may be useful, their fine grain favoring resolution of planetary details. Shorter exposures of smaller images should also be explored on these films.

My method of photographing planets is to project their images through a microscope objective or eyepiece onto the 35 mm. color film in a single-lens reflex camera. The camera lens is removed and an extension tube inserted to hold the film perpendicular to the optical axis, with focusing on the

camera ground glass. Usually I place two pictures of a planet on each frame, and at least 10 or 20 pictures are taken at each observing session. Almost invariably one or two of them will have superior detail, the rest being more affected by air turbulence, camera or telescope motion, or poor focus. Image motion can be reduced by setting the camera shutter for a time exposure and manually removing a cardboard shield to admit light to the telescope tube. A clock-driven equatorial mounting helps, and is essential when focal lengths of 600 inches are used with exposures of one half second or more.

For color prints, I first make 3X enlargements onto Kodachrome film. Since the brightness range of a planet image is limited, the camera film may be underexposed, appearing dark on projection. The shorter exposure times give maximum image sharpness. Enlarging and rephotographing brings the pictures to normal brightness and raises the contrast substantially. Prints made from these enlargements include further enlargement and increase the contrast and color saturation, with pleasing results. (See *Sky and Telescope,* Aug. 1963, for more complete coverage.)

In addition to the above, Mr. Keene has provided the following latest information. Current High Speed Ektachrome (daylight ASA 160) has a finer grain than the original film. It can be force processed to give good quality at speeds of 400. For prolonged exposures High Speed Ektachrome and Kodachrome-64 actually have similar speeds, *about* 12 at 20 min. and 6 at 4 hours; in fact Kodachrome-64 should be tried for exposures *over* 30 min., since it maintains good speed and color balance. With other films for a neutral balance try a CC20 red filter for prolonged exposures.

Planets are well recorded on either Kodachrome-64 or Ektachrome-X. The latter provides vivid colors, can be force processed to higher speeds, and maintains proper color balance on exposures up to 5 seconds. With lens or telescope of $f/4$ or faster and exposures of 10–60 min., you can photograph the brighter nebulae using High Speed Ektachrome or Kodachrome-64. Keene and Sewell of Eastman Kodak have an evaluation of off-the-shelf color films in *Sky and Telescope,* July 1975, pages 61 to 65.

<center>14</center>

SPECIAL TECHNIQUES

HIGH-RESOLUTION ASTROPHOTOGRAPHY
by Tom Osypowski and Tom Pope

A moderate-size telescope of high quality shows a breath-taking amount of lunar (Fig. 143) and planetary detail visually. But when an attempt is made to capture this fine detail on film, the results are inferior more often than not. The making of high-resolution astronomical photographs is almost an art, demanding care, proper technique, and not a little bit of luck. Here are five essential requirements:

EXCELLENT SEEING — Seeing, the steadiness of the air, is undoubtedly the most important single factor in astronomical photography. As a rule of thumb, if fine detail approaching the limit of resolution of the telescope cannot be seen visually, it will not be photographed either.

EXCELLENT OPTICS — Obviously, the telescope should be of the highest optical quality. A mediocre mirror or objective will spread light that blurs out fine detail, reducing image contrast.

PERFECT FOCUS — Particularly when eyepiece projection is used, focusing must be critical. One of the most convenient arrangements for the amateur is a 35 mm. reflex

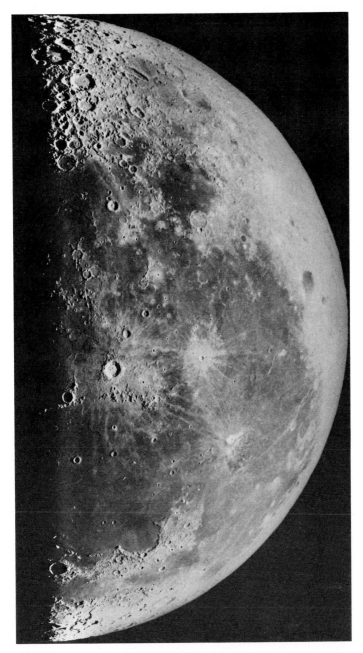

Fig. 143. Superbly sharp photo of last-quarter moon as seen in a 50-power telescope. Plato's crater is near bottom. (see upper Fig. 144 closeup). 1/15 sec. at f/9 (prime focus) on Adox Dokupan with 12½-in. f/7 Cave reflector. By T. Osypowski.

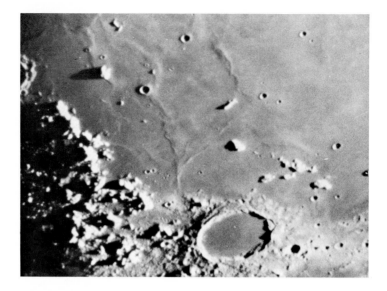

Fig. 144. High resolution photographs. (top) 250-power surface detail. The 7000 ft. isolated spire of Piton (top left) with its fingerlike shadow and the flat gray-plained great Plato crater (lower right). 1 sec. at f/70 equivalent projection on Pan-X film. By T. Pope. (bottom) The spidery Huygens Clefts; note crater interruption. 1 sec. at f/64 equivalent eyepiece projection on Kodachrome-X. By T. Osypowski. Both photos with 12½-in aperture f/7 Cave reflecting telescope.

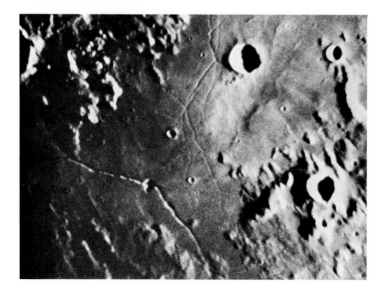

camera body attached to the eyepiece holder with extension tubes for projection photography (Fig. 144). The ground glass screen in some of these cameras can be replaced with clear glass and a cross-hair pattern. When both the image and the cross hairs are sharp in the camera's viewfinder the telescope is properly focused. This system is far superior to using ground glass or "focusing" screens.

In designing an adapter for the camera body, provision should be made for introducing a highly corrected projection eyepiece or Barlow lens, such as the Dakin Barlow by Vernonscope, into the optical train. Used 16 mm. or 35 mm. movie camera lenses make inexpensive but excellent projection optics. As a rule they are far superior to even the best orthoscopic eyepieces. When used with an amplification of $3X$ or more they will easily cover sharply a full 35 mm. frame.

ACCURATE GUIDING — A $12\frac{1}{2}$-inch telescope can theoretically resolve detail less than half a second of arc. Therefore, with such an instrument, *unguided* exposures of the moon and planets must be kept shorter than about 1/15 sec. If longer exposures are needed, a smooth running clock drive is indispensible.

Even with a sidereal drive, exposures of the moon should not be longer than about one second, because of the moon's eastward motion relative to the stars. Fortunately, even slow films rarely require longer exposures than this.

During the exposure there must be no vibration, and the biggest offender in this area will probably be the camera shutter. If the telescope is not massive enough to effectively dampen such vibration, then a large card held over (but not touching!) the front of the tube can be moved aside to make the exposure while the camera shutter is open and returned *before* closing.

PROPER FILM AND F/RATIO COMBINATIONS — The film must be capable of resolving all the detail a telescope can show (Fig. 145). Film resolution is usually expressed as the number of lines per millimeter that can just be distinguished separately on it. Manufacturer's test charts have high contrast such as alternate black-and-white lines, but the contrast on the moon and planets is much more subtle. For this reason, the film should have a theoretical

resolution about three times that of the telescope. (Note, here we are talking about *linear* resolution at the film plane, which is a function of the equivalent f/ratio of the total optical system.)

Suitable films for varying equivalent f/ratios are as follows: for $f/20$ — Kodak High Contrast Copy film; for $f/40$ — Kodak Panatomic-X; for $f/80$ — Plus-X or Tri-X, according to application and objective.

Color film can be used to advantage, especially on the planets. Choice of film is crucial, since different emulsions vary greatly in their rendition of subtle planetary hues. Kodachrome-64 and High Speed Ektachrome both seem to be good films in their ability to record color rather faithfully. Even so, varying sky conditions, differences in film batches and processing play havoc with any attempt to attain really con-

Fig. 145. High definition star photography. The Pleiades, or seven sisters, with attending nebulosity as photographed by Alan McClure. 7-in.-aperture f/7, 49-in.-focus Fecker Triplet lens. 20-min. exposure on 103a-O plate. About 2X enlargement.

 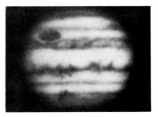

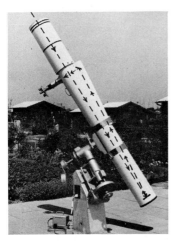

Fig. 146. Spectacular planetary photos with an 8-in.-aperture refractor. These superb photos of Jupiter and Saturn were taken with the 8-in. f/20 long focus "folded" refractor shown with light path indicated. Jupiter, 3 sec. at f/120 projection; Saturn, 10 sec. at f/110 projection. 10-DIN film. Composite enlargements, by G. Nemec, Munchen, West Germany.

sistent results . . . unless one can afford the time and money in maintaining quality laboratory conditions.

Determining proper exposure times is still a hit-and-miss affair, what with all the variables involved in astronomical photography. Some of the newest single-lens reflex cameras incorporate a spot exposure meter behind the mirror or ground glass, which might give useful readings. The following chart can be used as a rough guide, but bracketing of exposure times is still essential:

FILM	GIBBOUS MOON	JUPITER	SATURN
Panatomic-X	½–1 sec. at $f/64$	2 sec. at $f/90$	4 sec. at $f/64$
Plus-X	¼ sec. at $f/90$	½ sec. at $f/90$	2 sec. at $f/90$
Kodachrome-64	½–1 sec. at $f/45$	4 sec. at $f/90$	8 sec. at $f/64$

See *Sky and Telescope,* Jan. 1965, at your library for details. Fig. 146 illustrates fine high-resolution photography — a challenge to any 8- to 12-in. telescope owners.

LOW TEMPERATURE ASTROPHOTOGRAPHY
by Evered Kreimer

A most challenging segment of amateur astronomy is the photography of deep sky objects, an area usually left to the professionals. Considerable ingenuity, patience, and practice are needed with modest equipment; but striking photographs make up for the time spent. One fascinating method that goes beyond the usual techniques is that of taking pictures while the film is at temperatures far below freezing. This method has given some truly amazing results — only modest exposure times are needed to obtain photographs of faint nebulae (Fig. 147) and galaxies (Fig. 148) — rivaling those taken by tedious prolonged exposure or by much lower

Fig. 147. (top) The Veil nebula (NGC 6960), 10-min. exposure at minus 109°F. on Tri-X. (bottom) The same area, 10-min. at 70°F.; the veil is just starting to record. By E. Kreimer.

142

Fig. 148. (left) Part of the great Andromeda nebula (M 31), 10-min. exposure, Tri-X film at minus 109°F. (right) The right portion of same area, 10-min. at 70°F. Low temperature provides a spectacular gain in film efficiency. By E. Kreimer.

aperture ratio instruments. All work has been done with a 12½-inch *f*/7 reflector, quite a modest size by professional standards. Much could be accomplished with the average amateur's 6- or 8-inch *f*/8 reflector using this low temperature technique.

BACKGROUND INFORMATION — Very long exposures are necessary to get good density on deep sky photographs with commonly available films because of their poor sensitivity to the low intensity light from these distant objects. Indeed, it may not be possible to record very faint light at all in a reasonable exposure time. To reduce exposure time, one can select a "hot" film by testing different code dates under long exposure conditions in the darkroom or use special spectroscopic type films. Other methods would be treating the film chemically, baking, and flashing the film with light before exposure. But these give varying degrees of fog, which may be objectionable. Gains are most often quite modest. It has been known for a long time that low temperatures will decrease the sensitivity of an emulsion to light of high intensity, yet increase it at very low intensities. While this reversal of the reciprocity failure effect at low temperatures is just what is needed to permit shorter exposure times, only in very recent years has any serious effort been made to put this effect to use in astronomy.

SOME PROBLEMS — Cooling the film below the dew point of the air will cause moisture to condense on the surface. Of course when the film is below freezing, frost will form. Keeping frost off the film surface, then, is the most difficult problem to contend with. One method of doing this is to place the film in a chamber having a front window facing the objective, the film back resting on a cooling plate at the rear. Dry air can then be used to "flush out" the chamber before it is sealed. Making air absolutely dry is difficult, to say the least. Also, because of a refrigerator action, frost soon forms on the outside of the window, necessitating a heater. The air in the chamber conducts much heat to the film. A far better method is to evacuate the air from the chamber with a vacuum pump. A Cenco pump is used, but any pump pulling down to about .1 mm. of mercury will suffice. Not only is the moisture removed, but good insulation results as well.

CONSTRUCTION — Only a few construction hints, a schematic drawing, and a photo will be given here, as anyone building a similar unit will probably want to try other ideas or improvements. As shown in Fig. 149 (left) the chamber is constructed of heavy sheet metal (heavy enough so that air pressure will not bend it) and soldered. The window is bonded to the chamber with silicone rubber, and the gasket around the top of chamber, on which the cold box frame rests, is also silicone rubber. The film holder sits on a lucite rest for insulation, which must be strong enough

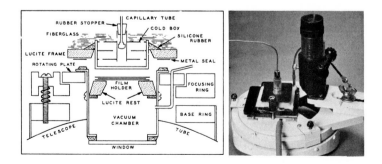

Fig. 149. (left) Schematic drawing of vacuum chamber—guiding head unit. Expanded carbon dioxide gas serves as coolant. (right) The complete unit with guiding microscope "ready to go," as built by E. Kreimer.

144

to support the atmospheric pressure on it coming from the area of the cold box. Because the cold box has atmospheric pressure on it, it must be constructed heavily enough not to bend and cause the film holder, which is in contact with it, to go out of focus. The cold box is bonded with silicone rubber in a lucite frame for insulation.

The cold box can be cooled by filling with dry ice chips, or more conveniently as illustrated, by allowing liquid CO_2 from a bottle to escape through a small orifice and into the box — the liquid turning to snow instantly — yielding about *minus* 109° Fahrenheit (F). An accurate way to control temperature, albeit expensive, would be to use a thermo-electric device for cooling. It is essential that there be no leaks, for even though the pump can maintain the vacuum, moisture in the air coming through the leak will form frost on the film.

OPERATION — The vacuum chamber is mounted and used in the form of a guiding head as shown in Fig. 149 (right). It consists of a base ring that fastens to the telescope tube at the Newtonian focus. On the base ring, a focusing ring is mounted with three spring-loaded screws. A plate, rotatable 360 degrees, supporting a guiding microscope goes in the focusing ring. The vacuum chamber is then mounted in the center of the rotating plate. A different method of mounting the vacuum chamber would be used, of course, in installations where a separate telescope is used for guiding.

To operate, the object to be taken is centered, a guide star found with the microscope, the film holder placed on the rest, and the cold box put down in place. After the vacuum pump has run a couple of minutes, the dry ice can be admitted or the CO_2 expanded and the exposure begun. When taking a series of pictures, the cold box must be allowed to warm up a bit so that moisture can be wiped off the platen before starting.

BLACK-AND-WHITE RESULTS — Some types of emulsions will show much larger speed gains than others. And each type will have an optimum exposure temperature. As temperature control seems difficult in this simple camera using dry ice, a film that shows the fastest speed at the fixed temperature of dry ice must be used. In most cases, this will be with Tri-X in 120 rolls. Almost all my picture

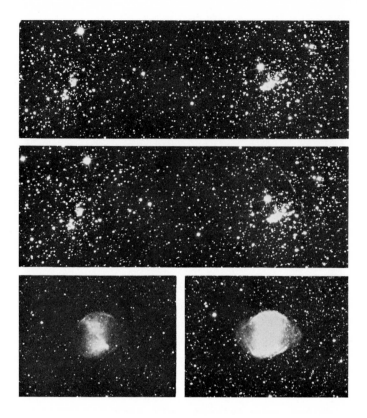

Fig. 150. (top pair) Compare the dazzling Perseus double cluster, 30-min. exposure at 50°F., with only 5 min. at minus 109°F., as shown directly below. Essentially identical recording. (bottom pair) The weird Owl nebula (M 27) emerges brightly on going from 10-min. at 50°F. to 10-min. at minus 109°F. All on Tri-X film, 4-min. development in D-19, by E. Kreimer.

taking has been done with this film, with a tendency towards standardizing all exposures at 10 minutes with the $f/7$ system. This exposure time can reach better than 19th magnitude. If a cooled and an uncooled picture are taken of the same object, both exposed for the same sky fog density, the cooled one will show bright areas as being noticeably less "burned in." Carrying this non-linearity a step further, a cooled picture can be given two or three times the "normal" exposure time, and can then be developed in a low-contrast developer such as UFG or diluted D-76. The resulting negative can be printed on #5 paper with little or no

dodging and will show detail in the bright areas. Cooling makes the exposure necessary for this technique a practicality. Overexposure and underdevelopment also improve the "signal to noise ratio."

Two other examples of the speed gain on Tri-X with cooling are shown in Fig. 150. The pair of Perseus double cluster photos exposed to the same sky fog density and the owl nebula pair at equal times show most effectively the low temperature advantage. If these comparisons had been made during cold winter time temperatures, the gain would be noticeably less.

COLOR RESULTS — Experimenting has been done with just one color film, High Speed Ektachrome (daylight type), and speed gains with cooling seem to run about three to six (Fig. 151). However, speed gains aside, many code dates will show a more important substantial improvement in color balance. Other code dates show little, the color balance being quite good even on a long, uncooled exposure. These variations result because the three emulsion layers react differently to cooling. By testing a particular code date in the darkroom beforehand, the exact color balance with cooling could be determined by comparison with a standard. Pictures taken on this code date could then be viewed through the proper color correction filter. Actually, the color variations between different emulsions are relatively small when they are cooled. The eye is able to adapt and ignore these differences quite easily, unless of course one is trying to make an identical match between two pictures.

As in black-and-white photography, cooling reduces "burning in" of bright areas on color also. For Fig. 151 the dodging necessary to show detail in the bright area may not be precisely accurate. But the sky fog and faint details are seen to be approximately the same on each, while the cooled picture shows less exposure in the bright area. With this sample of film, the color balance was nearly identical on both. Much detail shows on the original cooled transparency not reproducible on a print, and it would have to be considered superior to a black-and-white negative for this particular object.

Exposure time on cooled High Speed Ektachrome with the $f/7$ system is about 60 to 90 minutes when it is desired

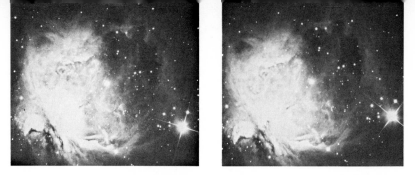

Fig. 151. (left) A 20-min. exposure on High Speed Ektachrome film at minus 109°F. is equivalent to a full hour's tediously guided exposure on uncooled film, as shown at right. Panatomic-X copies from Ektachrome originals through dodging mask to maintain detail in bright areas. By E. Kreimer.

to get well down into the sky fog for very faint objects. As color film does not seem to have the contrast of black-and-white, these faint objects will not show up well on the bright background. To improve the contrast and overall appearance, the original is copied onto reversal color film, such as Ektachrome, with an exposure so that the sky background will be darker and closer to what might be termed "normal." Although contrast is improved, faint reds and blues will tend to be lost in the copying process unless a light magenta filter such as Wratten CC10M or CC20M is used. Sometimes the original will have a greenish cast to the unexposed base and denser magenta CC filtering will be needed to keep the green color from getting out of hand on the copy. Other CC filters can be used in addition if it is desired to exaggerate slightly in the blue or red direction. With careful copying, the resulting picture can be almost spectacular, yet as genuinely true as color film can reproduce astronomical objects. Color requires longer exposure times than black-and-white, but the low temperature technique makes the results worth all the time spent at the telescope.

"COLD CAMERAS"

Mr. Kreimer has done an outstanding job in the area of "cold camera" photography. A beginner should be aware of some of the new developments, as well as the pitfalls. There have been dozens of methods recommended for increasing film speed, including heat, vacuum, dry nitrogen (may be dangerous), and so forth. A dry ice approach seems most practical, but for a newer approach write to the U.S. Patent Office, Wash., D.C. 20231 for a copy of Patent No. 3,667,358

(include 50¢). This is Williams and Usler's patent for the use of thick plastic plugs to avoid a vacuum chamber. Others have successfully used thick glass plugs — less danger of scratching. Usually two or more are interchanged. Commercial units are available, but expensive. As an alternative, try Eastman Kodak's 103a antihalation-backed films or plates.

References for Further Reading

The following books and articles are highly recommended. Some journal references prior to 1965 are retained because of their outstanding value. For later material it is far better to turn to *Sky and Telescope* or *Astronomy* to look up your area of interest. The area of astronomy has expanded tremendously and many libraries now have complete files.

BOOKS:

TELESCOPES FOR SKYGAZING by Dr. Henry E. Paul (Amphoto)—has a full chapter on astrophotography that presents many illustrations of outstanding amateur accomplishments; especially good reference for telescope equipment.
STARGAZING WITH TELESCOPE AND CAMERA by George T. Keene (Amphoto) —contains many hints of sound value for the beginning astrophotographer; should be on every amateur's bookshelf.

ARTICLES:

"High Resolution Photography" by Thomas Pope and Thomas Osypowski (*Sky and Telescope,* Jan. 1965, p. 52)—an unusually well-written and superbly illustrated article on astrophotography.
"Celestial Photography with an 8-inch Reflector" by James E. Gunn (*Sky and Telescope,* Sept. 1961, p. 149)—presents beautiful photos, details of equipment, film, development, and other information.
"Lunar Astrophotography with a 5-inch Refractor" by Stephen M. Larson (*Sky and Telescope,* Sept. 1966, p. 164)—eyepiece plus camera lens "afocal" method, film, filter, and development data.
"A Camera Adapter for Eyepiece Projection Photography" by Brenton Bennett (*Sky and Telescope,* Dec. 1965, p. 378)—equipment, techniques, and film.
"Star Field Photography with a Stationary Camera" by Stephen A. Walther (*Sky and Telescope,* Nov. 1964, p. 314)—ten- to twenty-second constellation photography.
"Sky Targets for Amateur Cameras—I" by Alan McClure (*Review of Popular Astronomy (RPA),* Sept.-Oct. 1962)—an outstanding, informative two-part article that every amateur astrophotographer should read; superbly illustrated, excellent on techniques and equipment; *RPA* out of print—consult your library.
"Sky Targets for Amateur Cameras—II" by Alan McClure (*RPA,* Dec. 1962)—continuation of the above.
"Instrumentation for Planetary Photography" by Tom Cave (*RPA,* Jan.–Feb. 1962) —planetary photography is discussed by the head of Cave Optical Co.
"Eyepiece Projection Techniques" by Steve Reed (*RPA,* Nov.–Dec. 1966, p. 26)— —for getting high magnifications.
"Skies in Color" by Harvey Randall (*RPA,* Feb.–Mar. 1966, p. 29)—color with Bushnell TeleVar; how to calculate exposure times.
"Astrophotography with an RFT" by Gregg A. Vane (*RPA,* Oct.–Nov. 1965, p. 26)— using an 8-in. *f*/4 "fast" reflector for deep sky objects.
"The Moon Through a 4-inch Refractor" by Steve Larson (*RPA,* April–May 1965, p. 24)—fine photographs with a small refractor.

IN CONCLUSION

It has been my pleasure to have traveled more miles and visited more amateurs involved in telescope making and astronomical photography than any other amateur in this hobby area—over a route covering part of Europe, and the U.S. from coast to coast. Should I be wrong it would be a pleasure to meet the contender.

Two things impress one most; the high caliber of the individuals and their work, and the wide variety of vocations of these amateurs to which outer space and related work has become an avocation. One finds students, research scientists, bankers, machinists, chemists, physicians, businessmen—in fact any profession you care to mention, all speaking a common language and working in a common field.

Here is a hobby for young or old. Our contributors range from a high school student who has taken high quality planetary photographs, to M. F. Taggart, who at the age of 69, took splendid photographs of atmospheric effects on the solar image (pages 68, 69).

No telescope is too simple or ancient for good work. In the small cut I am shown by a 6 inch reflector made over 50 years ago (in my teens) from molasses pails soldered together (aided by big brother Bill), an old buggy axle polar axis, and a silver coated paraboloid from a hand-edged chunk of green Pittsburgh Plate glass—encouraged by the work of Russell Porter and the A.G. Ingalls's then cracker thin 1926 edition of Amateur Telescope Making. Although plate glass often warps, the mirror still performs perfectly!

Nor is there a limit to your aspirations as indicated by Silva's and Dall's instruments and work.

Fig. 152.

Since this book contains absolutely nothing on sex or crime, it can never make the author a fortune; hence the real pleasure of compiling it rests in the friendly contacts made and in the hope of starting and guiding others in this rapidly growing area of universal interest—outer space photography.

It's always a treat to see and hear about other amateurs' accomplishments.

HENRY PAUL

APPENDIX: USEFUL FORMULAE

Always use same unit of measure throughout, i.e.—inches, millimeters, etc. A few abbreviations for most used expressions follow:

FL = Focal length. EFL = Equivalent focal length. D = Diameter of Objective (or mirror). M = Magnification. Eyp. = Eyepiece. Obj. = Objective or a parabolic mirror, as used in reflecting telescopes. / or — indicates division by the value below.

The use of f or $f/$ (number) is often misunderstood. The f *value itself* is the actual *ratio* of the FL to D or FL/D. Example: 8:1 or 15:1 or simply 8, 15, etc. The $f/$number, as commonly used, is f/f value =

$$1/f \text{ ratio} = 1/\frac{FL}{D} \text{ or simply } f/\frac{FL}{D}.$$

$$M \text{ OF A TELESCOPE} = \frac{FL \text{ Obj.}}{FL \text{ Eyp.}} = \frac{D}{\text{Dia. of exit pupil}}$$

TRUE USEFUL CLEAR APERTURE OF A LENS. Divide FL by f *value* (or the numerical part of the $f/$number). Example: a 6 inch focus $f/6.3$ W. A. photographic lens has a useful clear aperture of a little less than 1 inch, regardless of the much wider front element.

THE EFL OF A TELESCOPE *WITH* EYEPIECE COUPLED TO CAMERA *WITH* LENS. (Image is reversed, see Fig. 11b, page 13). Multiply instrument power (as marked on *its* eyepiece) or M by camera lens FL; or multiply the obj. FL times the camera lens FL and divide by the Eyp. FL.

$$\text{The f/number of this system} = f/\frac{EFL}{D}.$$

THE EFL OF A TELESCOPE WITH POSITIVE AMPLIFYING OR PROJECTION LENS (SYSTEM OR EYEPIECE) BETWEEN OBJ. AND FILM—*no* camera lens. (Image is reversed, see Fig. 11c, page 13). Multiply the FL of the obj. by the M of the projection system.

$$\text{The } f/ \text{ number of such a system} = f/\frac{FL \times M}{D} \text{ or } f/\frac{EFL}{D}.$$

To calculate M for positive amplifier systems, divide the distance from the lens to the film plane (secondary image) by the distance from the lens back to the focal point of the obj. (primary image). These two distances added equals increased instrument length.

The use of a negative lens (Barlow) as an amplifier as shown in Fig. 15, page 16, is often not well understood or appreciated. The small sketch and description will help clarify its use.

$$M = C/A$$

Camera film will move back a distance B and be at a distance A + B from the lens.

A Barlow lens is a negative lens (should be an achromat) which is placed between the original focal point (P) and the obj. at a distance A from P to produce an image of desired size at P', to the rear of the original focal plane. This image is *not* reversed. As the distance A is increased (up to the Barlow's focal length) the image at P' both increases and moves back to infinity (when A = Barlow FL).

$$\text{Formulae: } M = \frac{FL (M-1)}{A}; \text{ or } A = \frac{(M-1)}{M} \times FL;$$

$$\text{or } C = (M-1) \times FL$$

The above permits any calculation—Example: 6 in. Barlow 4 inches inside of focus (A = 4 in.) $M = \dfrac{6 \times (M-1)}{4}$ from which M = 3

(i.e. to check, 4 M = 12 and 6 (3 − 1) = 12); or if want an M of 4 times, then $A = \frac{4-1}{4} \times 6 = 4\frac{1}{2}$ inches that the Barlow must be moved towards obj. from P. Accordingly C = 18 inches and B = 13½ inches.

The diameter of the exit pupil (or Ramsden disc) is often a useful value. It is equal to D/M or $\frac{D \times FL \ (Eyp.)}{FL \ (obj.)}$. If disc dia. is measured then $M = \frac{D \ (obj.)}{disc \ dia.}$. To measure, point scope at bright area as sky (but not sun), move card or ground glass back and forth behind eyepiece and measure disc diameter at its smallest and sharpest point—use magnifier with measuring reticule on ground glass for small discs (high magnifications).

Current Manufacturers Every Amateur Should Consider

This revision required that a new approach be taken to provide information on suppliers. I'm still providing names of a limited number of companies "tried and proven" over the years, parts suppliers, and some new ingenious suppliers, with the hope they will continue to survive. Listed below, alphabetically by *key* part of name, are the firms (many new entries and addresses) plus short comments about their products.

AMERICAN SCIENCE CENTER (Chicago, Ill.)

AMPHOTO (Garden City, N.Y.)—publisher of my books and fine related books, specialize in photography.

ASTRONOMY CHARTED (Worcester, Mass.)—astronomical slide sets.

AUDY, G. E. (Wilmington, Del.)—excellent mirror mountings.

BURLEIGH BROOKS OPTICS INC. (Hackensack, N.J.)—cameras of all kinds, new and used, fine long-focus lenses.

BUSHNELL, D. P. & CO., INC. (Pasadena, Calif.)—a division of Bausch & Lomb Co., among the finest suppliers of binoculars and spotting scopes, also camera adapters, lenses, rifle scopes, etc.

BYERS CO., E. (Barstow, Calif.)—excellent drives and mounts.

CAVE OPTICAL CO. (Long Beach, Calif.)—large, dependable, long-established telescope makers; fine reflectors of almost any size desired; small refractors.

CELESTRON PACIFIC (Gardena, Calif.)—well-established maker of excellent Schmidt-Cassegrainian scopes, transportables 5-, 8-, and 14-in. apertures.

C. & H. SALES CO. (Pasadena, Calif.)—usable surplus items.

CLAUSING, D. L. (Skokie, Ill.)—fine Beral mirror coatings.

COULTER OPTICAL CO. (see *Sky and Telescope*)—relatively new source of *all* optics for astronomy.

CRITERION MFG. CO. (Hartford, Conn.)—established firm making fine 4- to 12-in. reflectors and an 8-in. Schmidt-Cassegrainian portable; their 6-in. reflector may be a best buy, although all are excellent.

EASTMAN KODAK CO. (Rochester, N.Y.)—best source of films and gelatin filters.

EDMUND SCIENTIFIC CO. (Barrington, N.J.)—an amateur's storehouse of optics, telescope accessories and economical scopes.

ESSENTIAL OPTICS (see *Sky and Telescope*)—8- to 18-in. reflectors plus finders on firm simple mounts at low cost.

E. & W. OPTICAL (Minneapolis, Minn.)—best reasonable source of 1/20 wave quartz or pyrex diagonals, also aluminum coatings and over-coatings.

HERBACH & RADEMAN (Philadelphia, Pa.)—excellent source of surplus motor drives and a multitude of useful items.

ILFORD (a Ciba-Geigy Co.) (Paramus, N.J.)—for films and filters.

JAEGERS, A. (Lynbrook, N.Y.)—best economical source of large (6-in. f/8-10 or 15) to small achromats plus a multitude of do-it-yourself scope parts.

LUFT, H. A. (Oakland Gardens, N.Y.)—for star atlases and books on astronomy such as *Norton's Atlas; A.T.M.* books I, II and III; etc.

MEADE INSTRUMENTS (see *Sky and Telescope*)—a relatively new company; eyepiece holders, superb guide scopes, camera adapters and hard to get do-it-yourself items.

NIKON, INC. (Ehrenreich Photo Opticals Industries, Garden City, N.Y.)—probably most versatile cameras and lenses available.

OLDEN CAMERA (New York, N.Y.)—at the crossroads of the camera business, new and used equipment.

OPTICA b/c (Oakland, Calif.)—quality supplies specifically for amateur astrophotographers and observers; an all-purpose company for kits, publications, unlimited accessories; complete scope line; four specialized catalogs.

PACIFIC INSTRUMENTS (Van Nuys, Calif.)—rings, drives, circles and mountings.

PANCRO MIRRORS INC. (Glendale, Calif.)—a highly reputable firm for optical coatings of all kinds.

PARKS, W. R. (Torrance, Calif.)—unsurpassed fiberglass telescope tubes (in colors) and mirror cells.

QUESTAR (New Hope, Pa.)—world famous 3½-in. Schmidt-Cassegrainian portable with a case size of a microscope it is a traveler's dream.

QUICK-SET INC. (Skokie, Ill.)—fine small tripods, best buys for three sizes of heavy-geared tripods for large equipment.

ROSENBERG, BEN (New York, N.Y.)—a "curio" shop for rare quality used items.

STAR-LINER CO. (Tucson, Ariz.)—reputable manufacturer of reflector telescopes, a line of economical, quality instruments.

TELESCOPTICS (Los Angeles, Calif.)—fine reflector eyepiece focusing mounts.

TUTHILL, R. W. (see *Sky and Telescope*)—a very ingenious new company; example: closed tube 4-in. Richfield reflector, perfect design, most reasonably priced; more innovations coming.

UNITRON SCIENTIFIC, INC. (Newton Highlands, Mass.)—recognized supplier of fine altazimuth, equatorial, and photo refractors; also accessories, especially refractor eyepiece mounts.

UNIVERSITY OPTICS (Ann Arbor, Mich.)—long established in economical telescopes, kits, finders and scope accessories for "do-it-yourself" builders.

VERNONSCOPE (Candor, N.Y.)—in my opinion, manufactures the world's best parfocal, wide-angle eyepieces (Brandon & Questar-Brandon); also the famous Dakin 2.4X Barlow.

Equipment and Supplies

Use the list below to find the names of various manufacturers or suppliers of the particular products you need.

ATLASES (star)—*Sky and Telescope*, Edmund, Luft, Optica b/c.

BARLOW LENSES—Vernonscope (best), Edmund, Jaegers, Telescoptics, Optica b/c.

BOOKS (astro)—*Sky and Telescope*, Luft, Amphoto, Edmund, Optica b/c, Telescoptics.

CAMERA BRACKETS (to adapt)—Optica b/c (among the best), Edmund, Criterion, Celestron, Bushnell.

CAMERAS (astro)—Criterion, Unitron, Optica b/c, Edmund, Bushnell, Celestron.

CAMERAS (with interchangeable viewfinders)—Nikon, Olympus OM-1 (compact and light weight), Canon, Miranda, Pentax (see camera journals).

CELLS (mirror)—Audy, Meade, Cave, Optica b/c.

CHARTS (rotating, etc.)—*Sky and Telescope*, Edmund, Optica b/c.

CIRCLES (setting)—Cave, Meade, Edmund, Optica b/c.

COATINGS (lens)—(aluminum and non-reflective)—Pancro (excellent), Clausing, E. & W. Optical, Miller, Woods.

CONTROLS (photo)—Edmund (low cost); good ones advertised in *Sky and Telescope*.

DIAGONALS—E. & W. Optical (best), Optica b/c, Jaegers, Unitron.

EYEPIECE HOLDERS—Telescoptics and Optica b/c among best.

EYEPIECES—Vernonscope (Brandon best), Edmund (low-cost), Jaegers, Telescoptics, Optica b/c, University, Meade.

FILM AND PLATES (astro)—Eastman Kodak, Ilford, Agfa, for small amounts; Optica b/c and offers in *Sky and Telescope*.

FILTERS—Eastman Kodak (gelatin), Nikon, Tiffon, Vivitar, Vernonscope (eyepieces).

FINDERS AND GUIDE SCOPES—Meade, Optica b/c, University Optics, most manufacturers.

LENSES (camera)—Nikon (excellent), Vivitar (very good), Canon (excellent), Leica (Leitz) (superb), Spiratone (some good buys when economy demands).

LENSES (large and small, mirrors, prisms, etc.)—Edmund, Jaegers (for large objectives), E. & W. Optical, Bausch & Lomb, C. & H. Sales.

LENSES (used-photo)—Olden, Rosenberg, Burleigh Brooks, C. & H. Sales, advertisements in *Popular Photography* and *Modern Photography*.

MAPS (star charts, etc.)—*Norton's Star Atlas* (a must), *Sky and Telescope,* Edmund, Optica b/c.

MIRRORS (cells)—Audy (best), Edmund, Cave, Meade and scope manufacturers.

MIRROR KITS—Telescoptics, Optica b/c, Precision, E. & W. Optical, Edmund, Criterion.

MIRRORS (reflectors, scopes)—Cave, Criterion, E. & W. Optical, Optica b/c, Pacific, Edmund, Coulter.

MOTORS (for driving)—Edmund (economical), E. Byers (excellent), Optica b/c, Pacific, Herbach & Rademan (surplus).

MOUNTINGS (equatorial)—Pacific, Cave, Star-Liner, Edmund, Unitron, Criterion.

OBJECTIVES (refractor)—Jaegers (the best buy for 6-in. or less, f/5 to f/15), Edmund, Cave, Rosenberg (used).

OPTICAL ELEMENTS (all kinds)—Edmund, Jaegers, Bausch & Lomb, E. & W. Optical, C. & H. Sales, Rosenberg (used).

OPTICAL GLASS—Bausch & Lomb, *Sky and Telescope*; Corning and G. E. for quartz, Cerevit, etc., new low exposure blanks.

SPIDERS—Audy, Telescoptics, Optica b/c, Edmund.

TELESCOPES (economical)—Edmund, Criterion, Jaegers (parts), Bushnell, Unitron, Sears, Montgomery Ward.

TELESCOPES (reflectors)—Cave, Essential Optics, Criterion, Star-Liner, Tuthill.

TELESCOPES (refractors)—Jaegers (best buys for lenses and parts), Cave, Edmund, Bushnell, Unitron, Criterion, Rosenberg (used).

TELESCOPES (special optics)—Questar, Celestron, Criterion (essentially Schmidt-Cassegrainian compact designs).

TELESCOPE SUPPLIES (miscellaneous)—best possible sources are advertisements in *Sky and Telescope,* Astronomy and all other journals available.

TRIPODS—Quick-Set, Edmund and war surplus outlets (see photo dealers).

TUBES—Parks and Meade for fiberglass tubes, Jaegers, Optica b/c and Edmund for aluminum.

USED INSTRUMENTS—best sources are "Sky Gazer's Exchange" in *Sky and Telescope* and "Astro-Mart" in *Astronomy,* or advertise with Rosenberg.

Literature and Books for Photographers and Observers

Every observer or builder of telescopes should subscribe to one or more of the following journals: *Sky and Telescope,* Bay State Rd., Cambridge, Mass. 02138, (caters to professionals, yet is loyal to amateurs—rich in equipment advertising); *Astronomy,* 757 N. Broadway, Suite 204, Milwaukee, Wisc. 53202, (relatively new, beautiful color outer space photos and superb artists' color renditions, latest professional information and fine practical articles for the amateur); *Modern Astronomy,* 18 Fairhaven Dr., Buffalo, N.Y. 14225, (a quarterly worth reviewing); *Astrograph,* Box 2283, Arlington, Va. 22202, (fine small bimonthly journal). Do not overlook smaller or local journals such as the *Reflector, Griffith Observer,* and so forth, which have sprung up by popular demand.

Regarding cameras and regular lenses see my other books and the magazines *Popular Photography* and *Modern Photography.* Always remember to check your library for the address of any publisher or journal.

Listed below are some useful books—current (C), earlier but good (E) and classic or old (O). Look for classics in libraries, used book stores or advertise for them. Please remember that astronomy and scope building are old arts and many earlier books are superb, informative and often even better than current books available—especially for history.

(C) NORTON'S STAR ATLAS by Norton and Inglis (Sky Pub. Corp.)—an absolute must for every photographer and observer, 16th edition just out, from *Sky and Telescope,* Luft or Edmund.

(C) THE AMATEUR ASTRONOMER'S HANDBOOK—1974 ed. by J. Muirden (T.Y. Crowell Co.)—This British author's fine book covers a little of everything; a useful reference book.

(C) ALL ABOUT TELESCOPES by Sam Brown (Edmund Scientific Co.)—for beginners, available in paperback from Edmund.

(E) ASTRONOMICAL PHOTOGRAPHY AT THE TELESCOPE by T. Rackham (Macmillan)—for 6-in. telescopes and larger, not recent but good, from *Sky and Telescope* and Edmund.

(E) SKYSHOOTING by Mayall and Mayall (Ronald Press)—excellent for beginners.

(E) AMATEUR TELESCOPE MAKING ed. by A.G. Ingalls (Scientific American, Inc.)—Books I, II, III, though approximately $10 ea., are a gold mine despite little or no indexing; beginners buy I from Luft, Edmund, *Sky and Telescope.*

(E) HOW TO MAKE A TELESCOPE by Texerau (Interscience Pub.)—outstanding for basic principles, involved yet readable, from Edmund or *Sky and Telescope.*

(E) MAKING YOUR OWN TELESCOPE by Thompson (Sky Pub. Corp.)—is the old "stand by" for detailed instructions, from *Sky and Telescope.*

(O) CELESTIAL OBJECTS FOR COMMON TELESCOPES (2 Vol.) by Webb (paperback now available through Dover Publishing Co.)—original volumes now collector's items—available from Edmund.

(O) THE TELESCOPE by L. Bell (McGraw-Hill)—very rare but filled with practical information and history, should be reprinted.

(O) THE HISTORY OF THE TELESCOPE by H.C. King (Chas. Griffin & Co. Ltd.) —The most complete history of telescopes every written—rare.

REGARDING JOURNALS—obtain those suggested or visit your local library and review carefully—especially available back issues. My older third edition (1967) of OUTER SPACE PHOTOGRAPHY has a fine review of earlier articles.

INDEX

DATE DUE